© PCM, Lyon, 2005

ISBN 2-914199-46-5

English: C.-S.-D.
Français: Clara Schmidt
Deutsch: Annett Richter
Español: Stéphanie Lemière
Русский: Любовь Евелева

Japanese Ornament
Ornement japonais
Japanische Ornamente
Ornamentación japonesa
Японский орнамент

Clara Schmidt

L'Aventurine

Contents • Sommaire • Inhalt • Índice • Оглавление

Foreword

Keen admirers of nature as the Japanese are, and fully alive to all the wealth of flower, foliage, and scenery in which their country is so exceptionally rich, it must not be supposed that their art is entirely the outcome of their own observation…

The power of the artist's effects, the wonderful facility of his execution, the beauty of the colouring and delicacy of drawing, all combine to give what may pass for a marvellous transcript of nature, but taken separately and examined critically, the objects depicted, be they bird, flower, leaf or insect, will be found incorrect in form, proportion, and construction, if judged by a European standard. Yet in these very failings are found their highest merits as decorative artists. Decorative art does not admit of absolute fidelity to nature; slavish copyists of nature, lacking imagination, can never be true decorative artists. The very essence of decorative art is the power of conventionalizing nature, while retaining all the spirit and feeling of the object represented, and this is where the Japanese especially excel.

Gifted with wonderful quickness of perception, and delicacy of hand, they can seize upon and reproduce, with extraordinary rapidity and power of touch, the characteristics of natural objects. Their method of writing is alone sufficient to give them great facility of execution, as all the letters—or rather characters—of the language are written with the brush, which they are thus accustomed to use from their earliest childhood… The Japanese artist learns to draw as he has learned to write. He does not sit down opposite a model or natural object and endeavour to represent it as it appears to him; as he learns to form the innumerable and complicated characters of his language by constant repetition, so does he acquire the power of drawing certain designs and conventional forms, by long continued copying of accepted models, which have been handed down from generation to generation. This very method of procedure, while fatal to the excellence which he might attain as a student of nature, gives him that decorative power in design in which, as we have said, the Japanese artist stands pre-eminent.

Thomas W. Cutler, *A Grammar of Japanese Ornament and Design*, London, 1880.

Avant-propos

Il ne faut pas supposer que l'art des Japonais, ardents admirateurs de la nature et pleinement réceptifs à la richesse décorative des fleurs, du feuillage et des paysages de leur pays, soit uniquement basé sur l'observation de la nature…

La puissance des effets artistiques, la facilité désarçonnante de l'exécution, la beauté des couleurs et la délicatesse du trait, tout se conjugue en une merveilleuse transcription de la nature. Pris séparément et examinés par un œil critique, les objets dessinés, qu'ils soient des oiseaux, des fleurs, des feuilles ou des insectes, seraient jugés malformés, mal proportionnés et mal construits selon les critères européens. C'est justement dans ces " défauts " que résident les plus grandes qualités des artistes-décorateurs japonais. Les arts décoratifs ne souffrent pas une fidélité absolue envers la nature. Les copistes en manque d'imagination ne peuvent jamais devenir de véritables artistes. L'essence même de l'art décoratif réside dans son pouvoir de styliser la nature tout en retenant la quintessence de l'objet représenté et c'est en cela que les Japonais excellent par-dessus tout.

Dotés d'une étonnante rapidité de perception et d'un toucher délicat, ces artistes parviennent à saisir et à reproduire les caractéristiques du monde vivant. La calligraphie à elle seule suffit à leur permettre une grande facilité d'exécution car tous les idéogrammes sont écrits à l'aide d'un pinceau qu'ils utilisent depuis leur plus tendre enfance. L'artiste japonais apprend à dessiner comme il apprend à écrire. Il ne se place pas en face d'un modèle ou d'un objet en s'efforçant de le représenter tel quel. De la même façon que, par une répétition constante, il apprend à former les innombrables idéogrammes compliqués de sa langue, il apprend à dessiner certains motifs et formes conventionnels en copiant ou en se basant sur des modèles repris du passé. Cette méthode même permet aux artistes d'interpréter la nature plutôt que de la reproduire.

Extrait de: Thomas W. Cutler, *A Grammar of Japanese Ornament and Design*, London, 1880.

Vorwort

Die Kunst der Japaner, als glühende Bewunderer der Natur empfänglich für deren dekorative Vielfalt bei Blumen, Blättern und Landschaften basiert keineswegs nur auf der Beobachtung. Die künstlerische Ausdruckskraft, die grazile Leichtigkeit in der Ausgestaltung und Strichführung, die Schönheit der Farben und Linien verbinden sich zu einer wunderbaren Interpretation der Natur. Einzeln gesehen und mit einem kritischen europäischen Auge betrachtet würden die verschiedenen Motive, Vögel, Blumen, Blätter oder Insekten, sicher für schlecht dargestellt, unproportioniert und falsch konstruiert gehalten werden. Gerade diese „Fehler" zeichnen die japanischen Künstler der Ornamentik aus, ihre künstlerische Freiheit in der Interpretation der natürlichen Schönheit und Vielfalt der Formen, Ihre Fähigkeit die Quintessenz all dieser Elemente zu erkennen und umzusetzen.

Dies unterscheidet sie von ideenlosen Kopisten und Nachahmern. Eine schnelle Auffassungsgabe und eine hohe Sensibilität befähigt die japanischen Künstler ihre lebendige Umwelt zu erfassen und umzusetzen. Dank der Kalligraphie können sie ihre Ideen schnell darstellen, denn alle Ideogramme (Begriffszeichen) werden mit dem Pinsel gezeichnet, einer Technik die sie seit ihrer frühesten Kindheit beherrschen.

Die Japaner lernen gleichzeitig zeichnen und lesen. Sie setzen sich nicht vor ein Modell oder einen Gegenstand und versuchen ihn zu reproduzieren. Sie lernen durch ständige Wiederholung und Variation die Formensprache der Ideogramme zu meistern, sie lernen die ungezählten Ideogramme in Sprache umzusetzen und umgekehrt, sie lernen Motive und Formen in konventionellen Figuren immer wieder zu zeichnen. Diese Methode erlaubt es ihnen, die Natur nicht nur schlicht darzustellen sondern sie gekonnt zu interpretieren.

Aus Thomas W. Cutler, *A Grammar of Japanese Ornament and Design*, London, 1880.

Prólogo

No hay que suponer que el arte de los japoneses – ardientes admiradores de la naturaleza y plenamente receptivos a la riqueza decorativa de las flores, del follaje y de los paisajes de su país – sea únicamente basado en la observación de la naturaleza...

La potencia de los efectos artísticos, la facilidad desconcertante de la ejecución, la belleza de los colores y la delicadeza del trazo, todo se conjuga en una maravillosa transcripción de la naturaleza. Tomados por separado y examinados por un ojo crítico, los objetos dibujados, ya sean pájaros, flores, hojas o insectos, serían considerados malformados, mal proporcionados y mal construidos según los criterios europeos. Es justamente en estos "defectos" que residen las mayores calidades de los artistas-decoradores japoneses. Las artes decorativas no tienden a una fidelidad absoluta para con la naturaleza. Los copistas por falta de imaginación nunca pueden llegar a ser verdaderos artistas. La esencia misma del arte decorativo reside en su poder de estilizar la naturaleza reteniendo la quintaesencia del objeto representado y eso es en lo que los japoneses se destacan particularmente.

Dotados de una sorprendente rapidez de percepción y de un delicado tacto, estos artistas consiguen percibir y reproducir las características del mundo vivo. La caligrafía a ella sola les permite una gran facilidad de ejecución ya que todos los ideogramas estan escritos con un pincel que utilizan desde la infancia. El artista japonés aprende a dibujar como aprende a escribir. No se pone frente a un modelo o un objeto tratando de representarlo tal cual. De la misma manera que, a través de una constante repetición, aprende a formar los innumerables y complicados ideogramas de su idioma, aprende a dibujar ciertos motivos y formas convencionales copiando o basándose sobre modelos tomados del pasado. Este mismo método permite a los artistas interpretar la naturaleza en vez de reproducirla.

Extracto de: Thomas W. Cutler, *A Grammar of Japanese Ornament and Design*, London, 1880.

Предисловие

Несмотря на то, что японцы обожают природу и живо чувствуют все богатство цветов, листвы и пейзажей, которыми изобилует их страна, не следует считать, что японское искусство целиком является результатом наблюдений природы... Сочетание силы художественных эффектов, удивительной легкости исполнения, красоты колорита и утонченности рисунка изумительно передает красоту природы, но взятые отдельно изображаемые объекты, будь то птицы, цветы, листья или насекомые, при критическом рассмотрении, если судить по европейским стандартам, имеют неправильные форму, пропорции и строение. Но в этих самых недостатках кроются величайшие достоинства работ японских мастеров декорации. Декоративное искусство не допускает абсолютной верности природе, художник с недостатком воображения никогда не сможет стать настоящим мастером декорации. Основная суть декоративного искусства заключается в условном изображении природы, в то же самое время сохраняются духовное начало и чувства, вызываемые изображаемым объектом, и в этом смысле японские художники являются непревзойденными мастерами.

Обладая удивительно живым восприятием и утонченностью творческой манеры исполнения, они постигали и были способны отобразить, с удивительной живостью и силой выразительности, характерные черты объектов природы. Их манера письма сама по себе обеспечивала им удивительную легкость исполнения, поскольку все буквы или иероглифы, выписывались кистью, которой они привыкли пользоваться еще в раннем детстве.

Японский художник учится рисовать одновременно с обучением письму. Он не сидит напротив модели или объекта природы и не стремится представить его таким, каким он ему кажется; он учится писать многочисленные сложные иероглифы своего языка путем постоянного повторения, таким образом, приобретая умение изображать некоторые узоры и традиционные формы, долгое время копируя принятые модели, передаваемые из поколения в поколение. Хотя такой творческий метод хотя и не позволяет достигнуть той высокой степени мастерства, какого можно было бы добиться при тщательном изучении природы, но предоставляет мастеру декоративные возможности при создании рисунков, в которых японские художники обладают непревзойденным талантом.

Thomas W. Cutler, *A Grammar of Japanese Ornament and Design*, London, 1880.

Flowers
Fleurs
Blumen
Flores
Цветы

16:
Vignettes, 19th century.
Vignettes, XIX^e siècle.
Vignetten, 19. Jh.
Viñetas, siglo XIX.
Виньетки, 19 век.

17:
Obi fabric with peonies and
chrysanthemums.
Tissu pour obi avec des pivoines et
des chrysanthèmes.
Stoff für obi mit Bauernrosen und
Chrysanthemen.
Tejido para obi con peonías y
crisantemos.
Ткань оби с пионами и
хризантемами.

18:
Left: Obi fabric with peonies. **Right:**
Cloisonné enamel.
À gauche: Tissu pour obi avec des
pivoines. **À droite:** Émaux cloisonnés.
Links: Stoff für obi mit Bauernrosen.
Rechts: Emailmosaikarbeit.
Izquierda: Tejido para obi con
crisantemos. **Derecha:** esmaltes
tabicados.
Слева: Ткань оби с пионами.
Справа: Эмаль клуазоне.

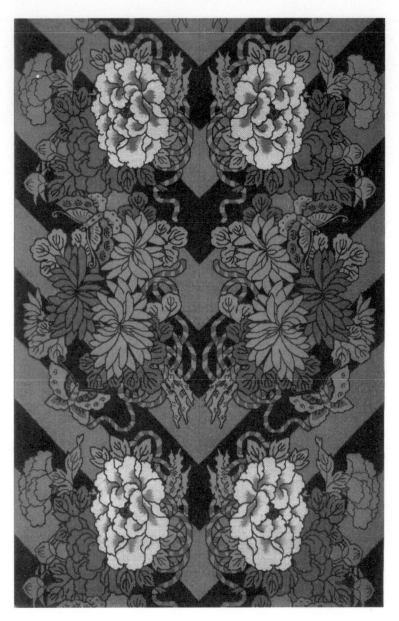

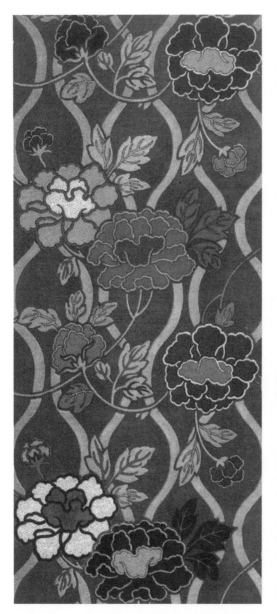
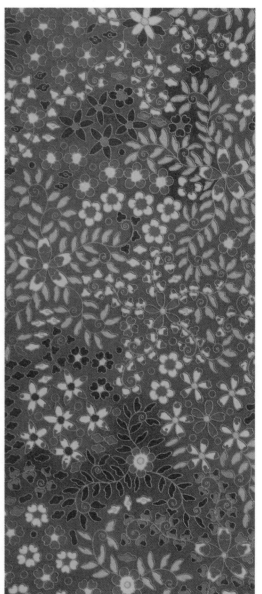

18

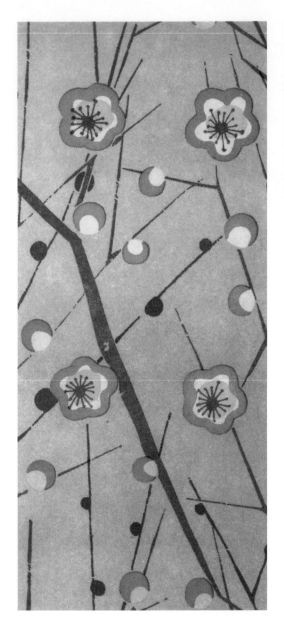

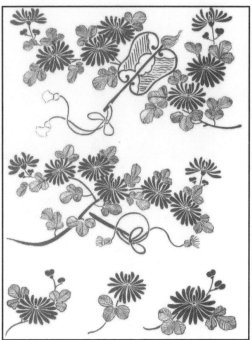

Left: Decorated paper with apricot blossoms.
Right: Stylized flowers.
À gauche: Papier décoré de fleurs d'abricots.
À droite: Fleurs stylisées.
Links: Geschmücktes Papier mit
Aprikosenblumen. **Rechts:** Stilisierte Blumen.
Izquierda: Papel decorado con flores de
albaricoque. **Derecha:** Flores estilizadas.
Слева: Декоративная бумага с
цветами абрикоса. Справа:
Стилизованные цветы.

Thomas W. Cutler. *A Grammar of Japanese
Ornament and Design,* London, 1880.

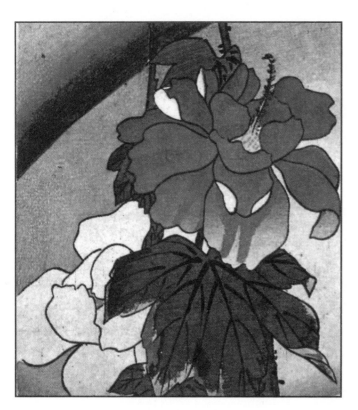

Rose and bird, Ukiyo-e, 1830.
Rose et oiseau, Ukiyo-e, 1830.
Rose und Vogel, Ukiyo-e, 1830.
Rosa y ave, Ukiyo-e, 1830.
Роза и птица, Уки·-е. 1830.

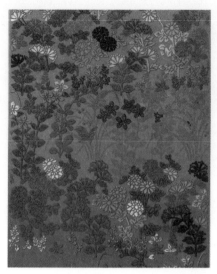

21:
Brocades.
Brocarts.
Brokate.
Brocados.
Парча.

22-23:
Silk and gold brocades.
Brocarts de soie et d'or.
Seiden und Goldbrokate.
Brocados de seda y oro.
Шелковая парча, расшитая
золотыми нитями.

George Ashdown Audsley. *The
Ornamental Arts of Japan,*
London, 1882.

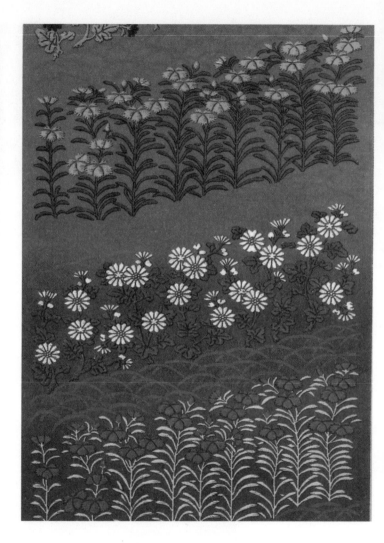

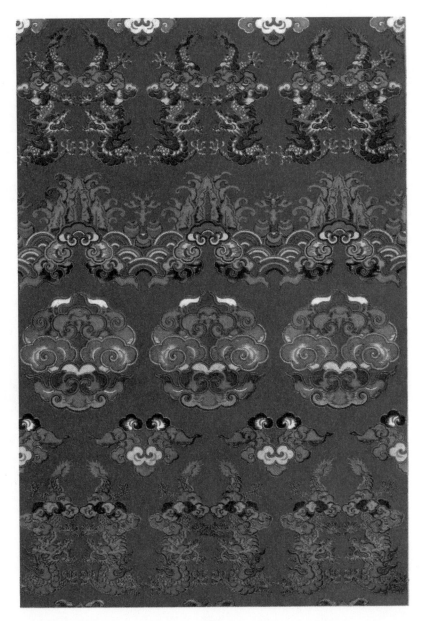

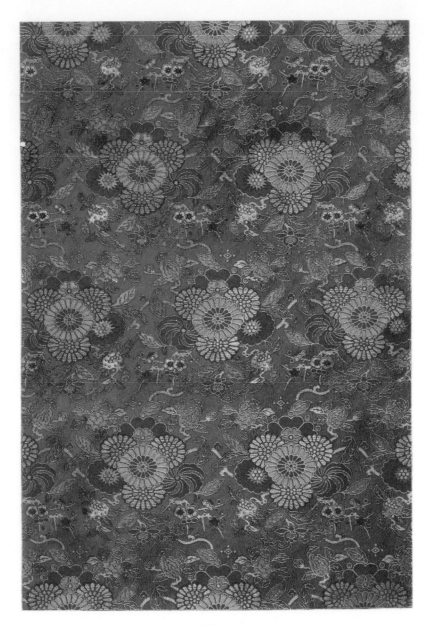

23

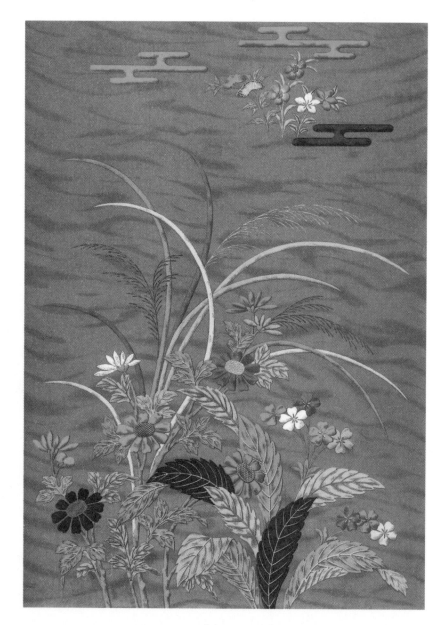

24

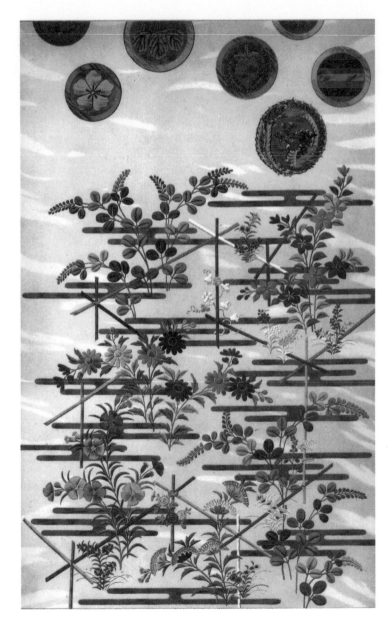

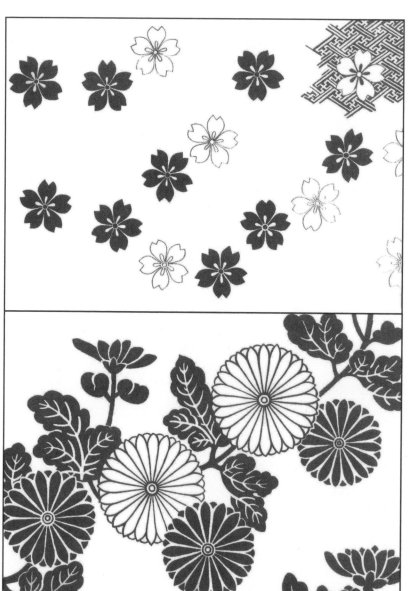

24-25:
Embroideries.
Broderies.
Stickereien.
Bordados.
Вышивка.

26:
Stylized flowers.
Fleurs stylisées.
Stilisierte Blumen.
Flores estilizadas.
Стилизованные цветы.

Thomas W. Cutler. *A Grammar of Japanese Ornament and Design,* London, 1880.

27:
Embroidered fabric with chrysantemums.
Tissu brodé avec des chrysanthèmes.
Bestickter Stoff mit Chrysanthemen.
Tejido bordado con crisantemos.
Ткань, вышитая хризантемами.

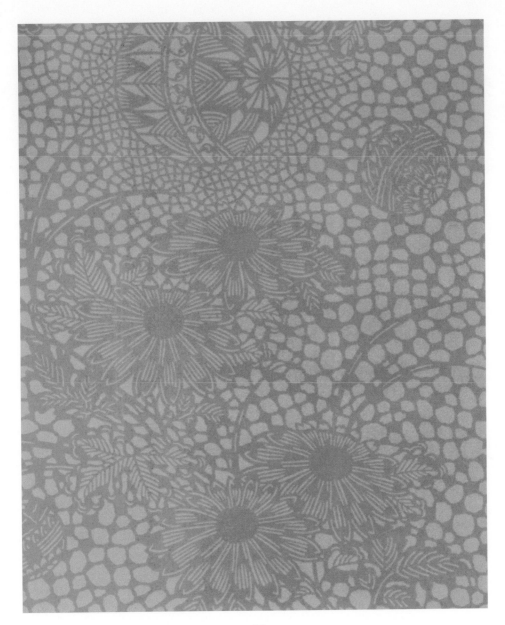

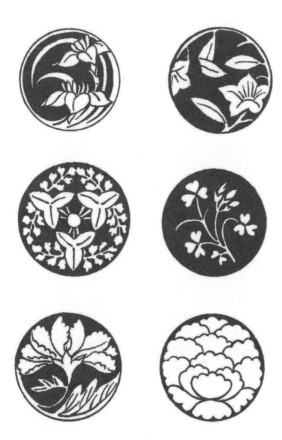

28-29
Stylized flowers.
Fleurs stylisées.
Stilisierte Blumen.
Flores estilizadas.
Стилизованные цветы.

Thomas W. Cutler. *A Grammar of Japanese Ornament and Design,* London, 1880.

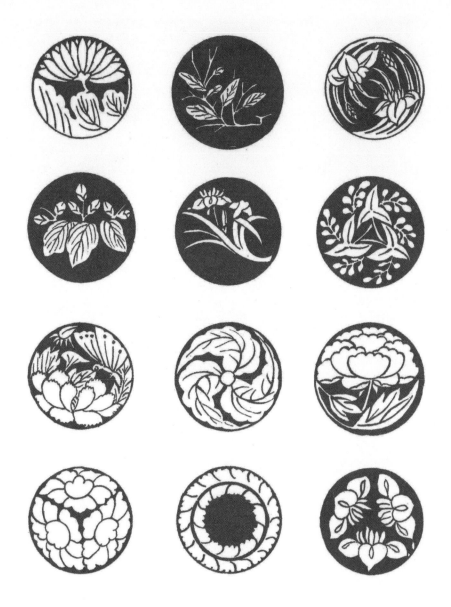

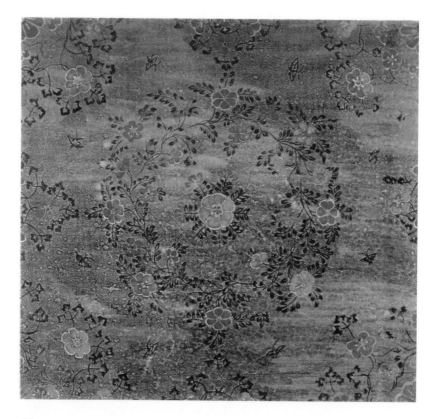

30:
Butterflies and flowers.
Papillons et fleurs.
Schmetterlinge und Blumen.
Mariposas y flores.
Бабочки и цветы.

31:
Cloisonné enamels.
Émaux cloisonnés.
Emailmosaikarbeit.
Esmaltes tabicados.
Эмаль клуазоне.

Albert Racinet. *L'Ornement polychrome,* Paris, 1869.

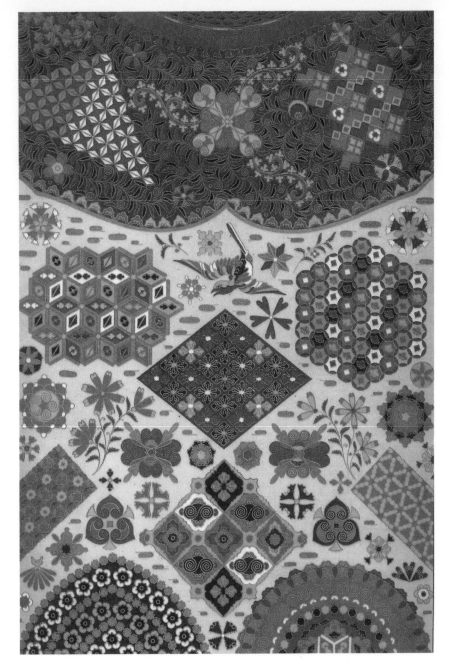

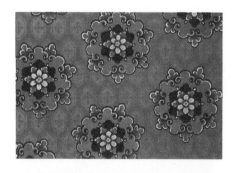

Stylized flowers.
Fleurs stylisées.
Stilisierte Blumen.
Flores estilizadas.
Стилизованные цветы.

Albert Racinet. *L'Ornement polychrome,* Paris, 1869.

Stylized flowers.
Fleurs stylisées.
Stilisierte Blumen.
Flores estilizadas.
Стилизованные цветы.

Thomas W. Cutler. *A Grammar of Japanese Ornament and Design,* London, 1880.

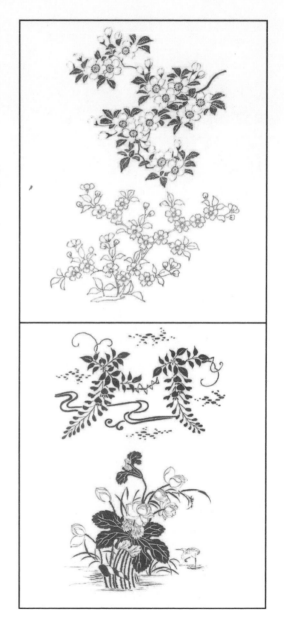

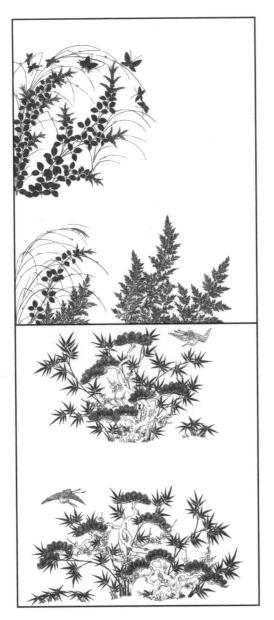

34-35: Stylized flowers.
Fleurs stylisées.
Stilisierte Blumen.
Flores estilizadas.
Стилизованные цветы.

Thomas W. Cutler. *A Grammar of Japanese Ornament and Design,* London, 1880.

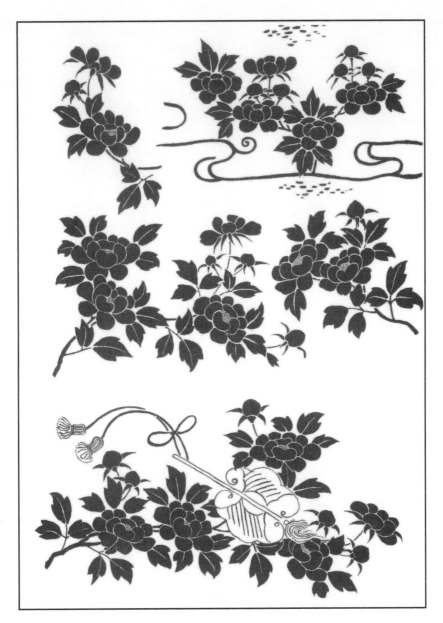

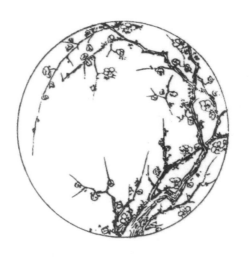

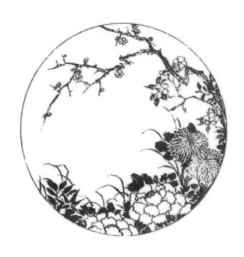

36

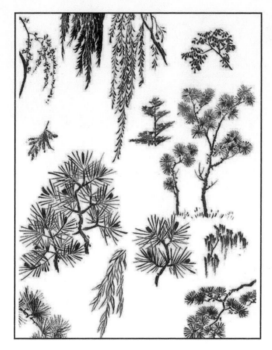

36-37:
Stylized flowers.
Fleurs stylisées.
Stilisierte Blumen.
Flores estilizadas.
Стилизованные цветы.

Thomas W. Cutler. *A Grammar of Japanese Ornament and Design,* London, 1880.

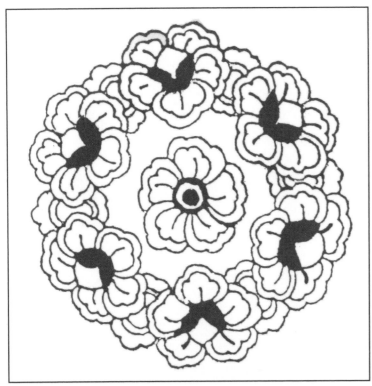

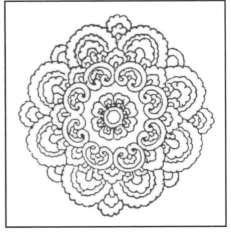

38:
Hand-mirror decorations.
Décoration de face à mains.
Hand-Spiegeldekorationen.
Decoración de espejos.
Декор для ручного зеркальца.

39:
Top: Batik design. **Bottom:** Fabric
with chrysantemums.
Haut: Motif de batik. **Bas:** Tissu
avec chrysanthèmes.
Oben: Batik Ornament. **Bas:** Stoff
mit Chrysanthemen.
Arriba: Motivo de batik. **Abajo:**
Tejido con crisantemos.
Наверху: Узор батик. Внизу:
Ткань с хризантемами.

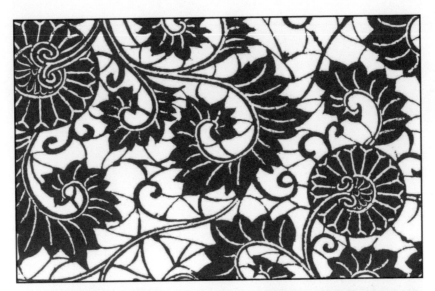

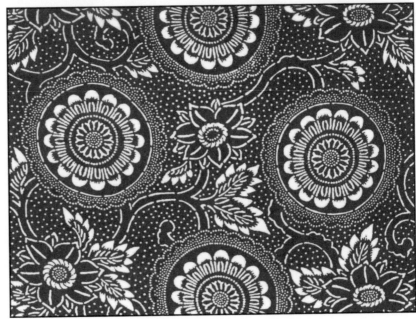

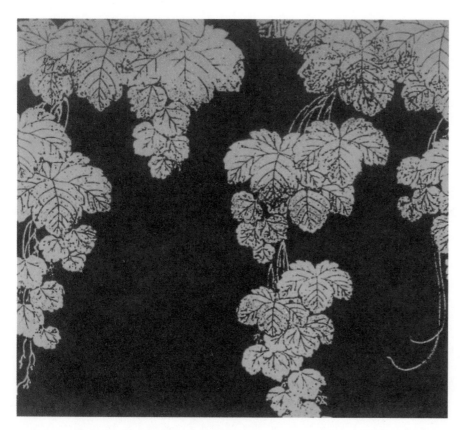

Lacquer.
Laque.
Lack.
Laca.
Рисунок, покрытый лаком.

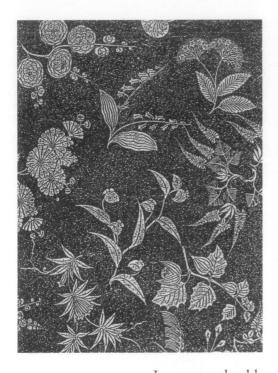

Lacquer and gold.
Laque et or.
Lack und Gold.
Laca y oro.
Рисунки, покрытые лаком и золотом.

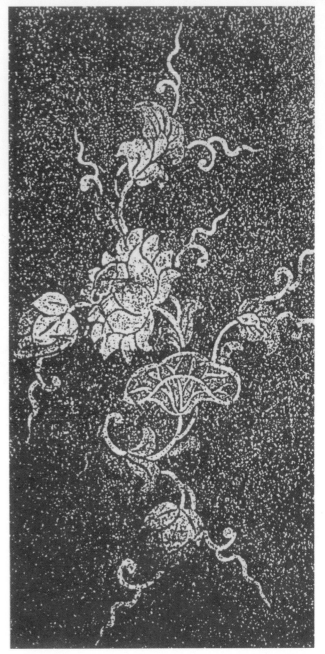

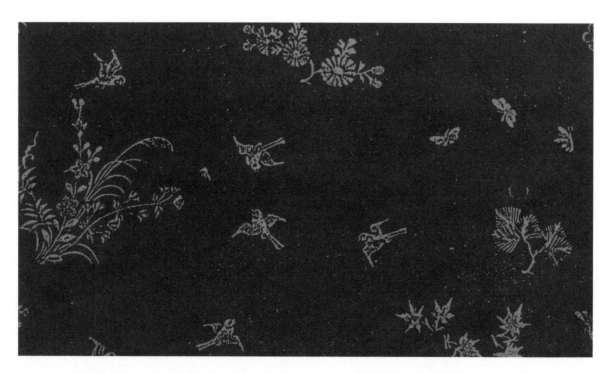

42:
Lacquer and gold.
Laque et or.
Lack und Gold
Laca y oro.
Рисунки, покрытые лаком и золотом.

43:

Left: Fabric with stylized flower patterns. **Top right:** Fabric with lotus pattern. **Bottom:** Tortoise shell and flowers patterns.
À gauche: Tissu avec des motifs de fleurs stylisées. **En haut à droite:** Tissu avec des motifs de lotus. **En bas:** Écailles de tortue et motifs de fleurs.
Links: Stoff mit stilisierter Blumen. **Oben, rechts:** Stoff mit lotosblumen. **Unten:** Schildkrötenpatte und Blumen.
Izquierda: Tejido con flores estilizadas. **Arriba, derecha:** Tejido con lotos. **Abajo:** Carey de tortugas y flores.
Слева: Ткань со стилизованным цветочным рисунком.Наверху справа: Ткань с рисунком лотоса. Внизу: рисунки с панцирем черепахи и цветами.

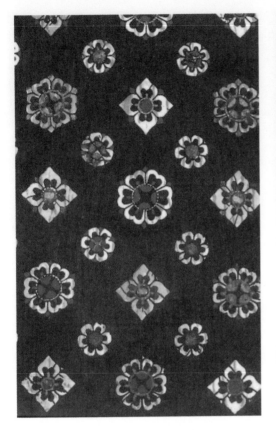

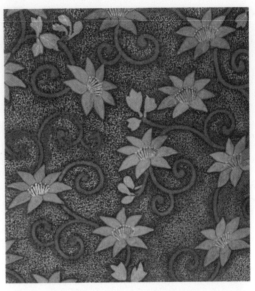

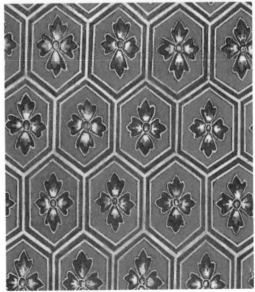

43

44-45:
Stylized flowers.
Fleurs stylisées.
Stilisierte Blumen.
Flores estilizadas.
Стилизованные цветы.

Thomas W. Cutler. *A Grammar of
Japanese Ornament and Design,* London,
1880.

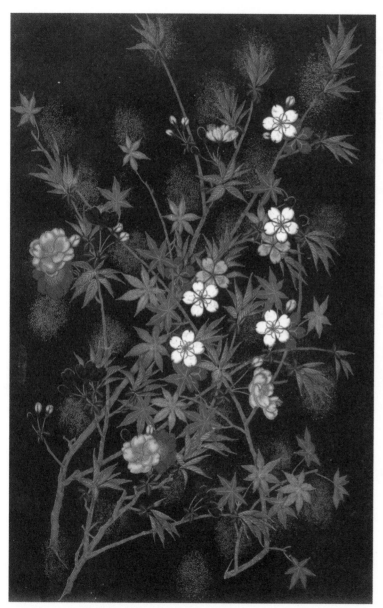

46:
Lacquer.
Laque.
Lack.
Laca.
Рисунок, покрытый лаком.

47:
Fabrics for book binding.
Textiles pour reliures.
Textilien für Binden.
Tejidos para encuadernación.
Ткани для книжного
переплета.

48:
Bottle with cloisonné enamel.
Bouteille avec des émaux
cloisonnés.
Flasche mith Emailmosaikarbeit.
Botella con esmaltes tabicados.
Бутылка, украшенная эмалью
клуазоне.

George Ashdown Audsley. *The
Ornamental Arts of Japan,*
London, 1880.

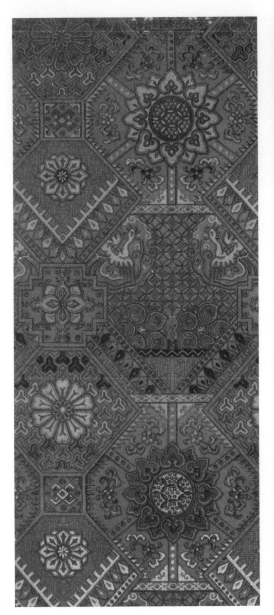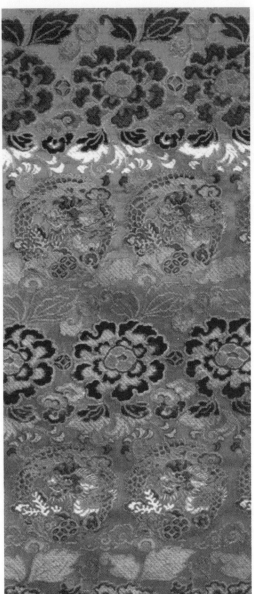

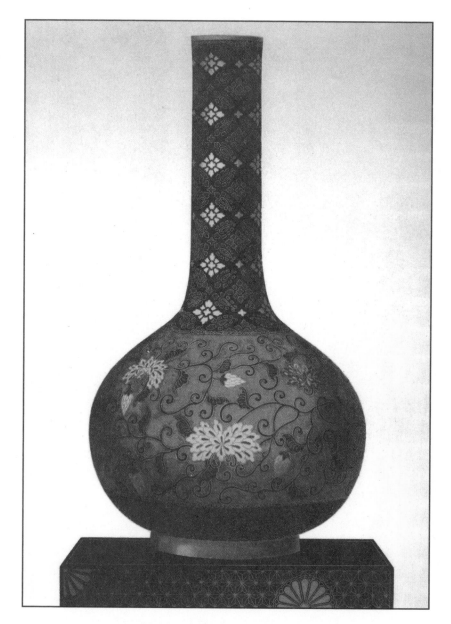

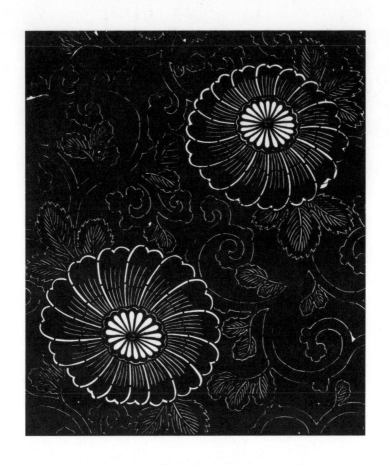

Japanische Motive für Flaäschenverzierung, Verlag der
Blätter für Architektur und Kunsthandwerk, Berlin, n.d.

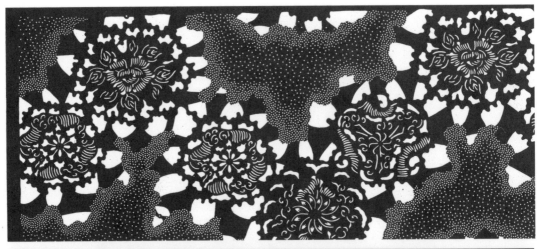

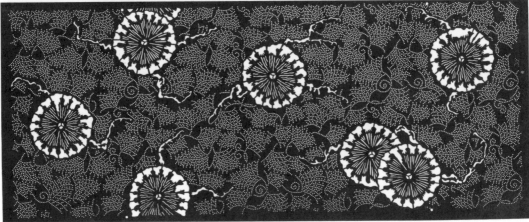

50-71:
Japanische Motive für Flaäschenverzierung,
Verlag der Blätter für Architektur und
Kunsthandwerk, Berlin, n.d.

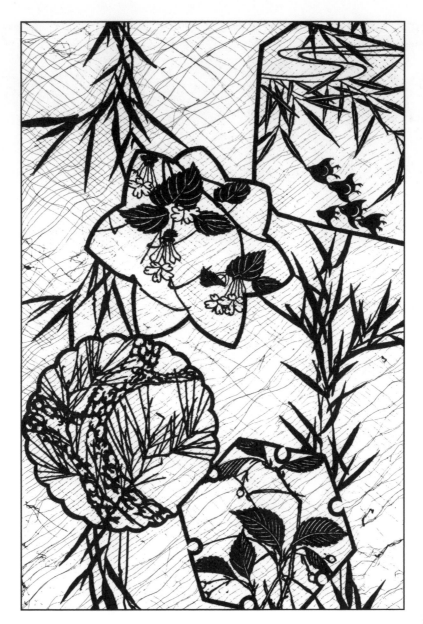

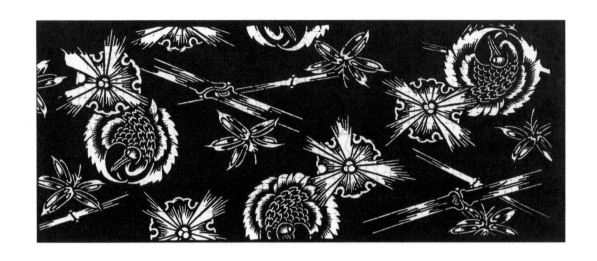

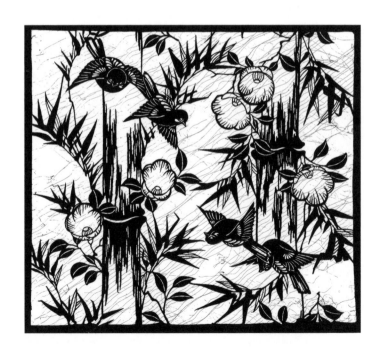

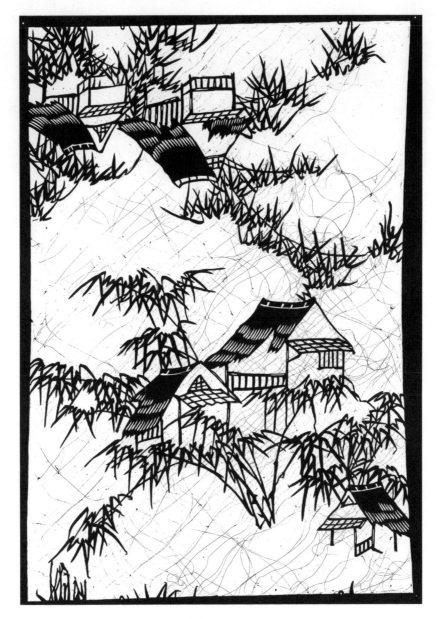

54

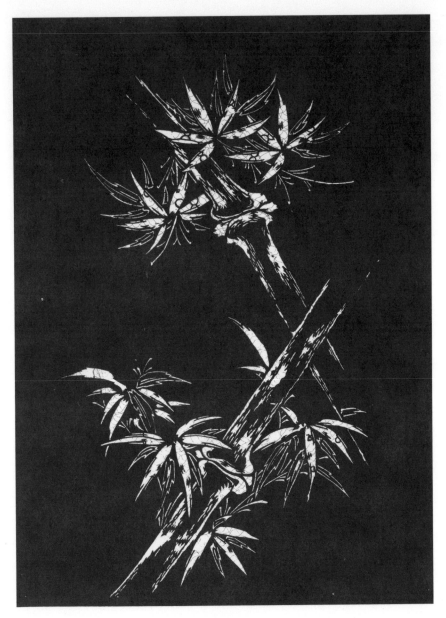

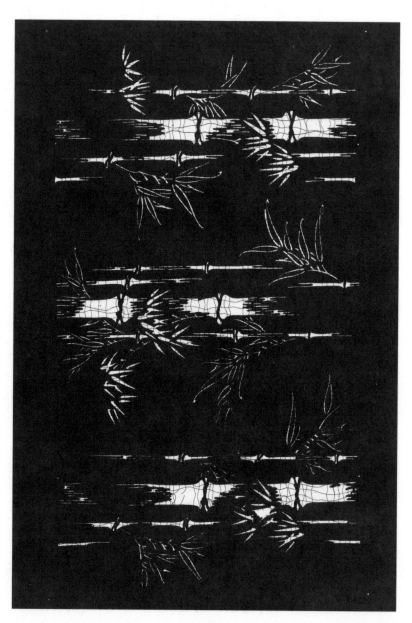

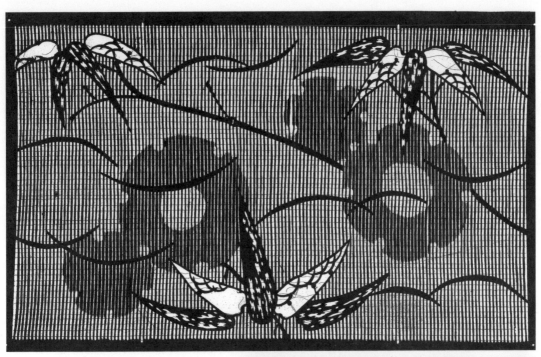

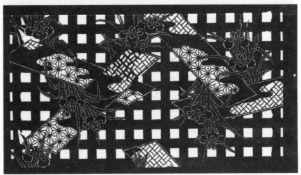

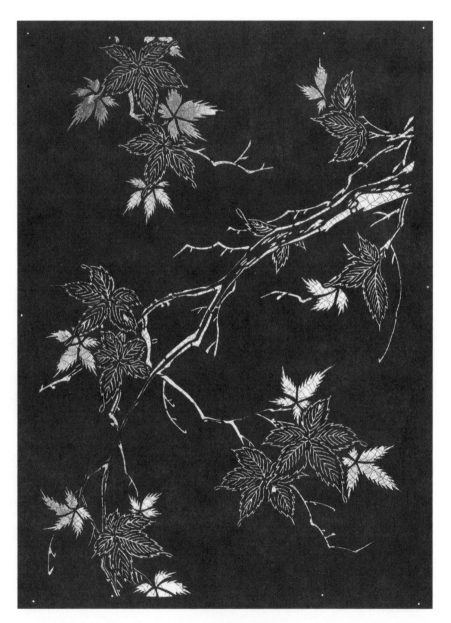

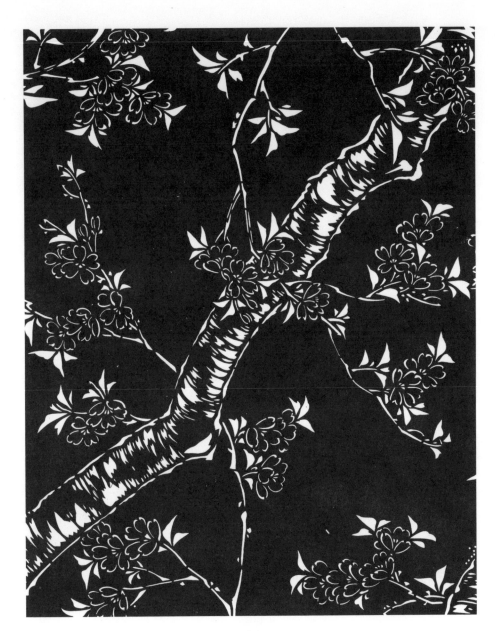

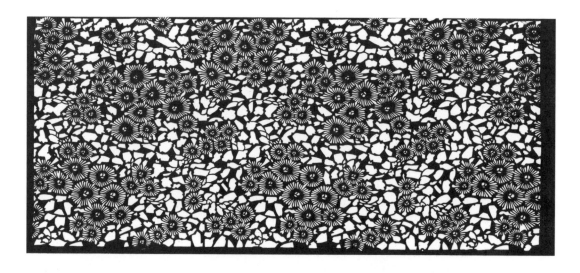

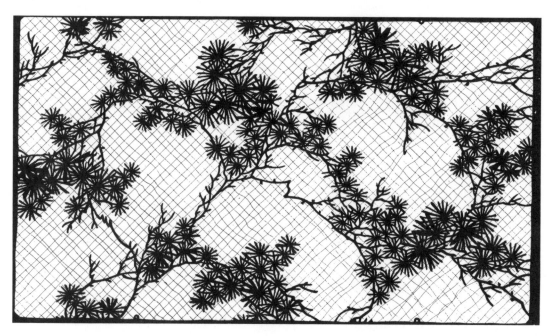

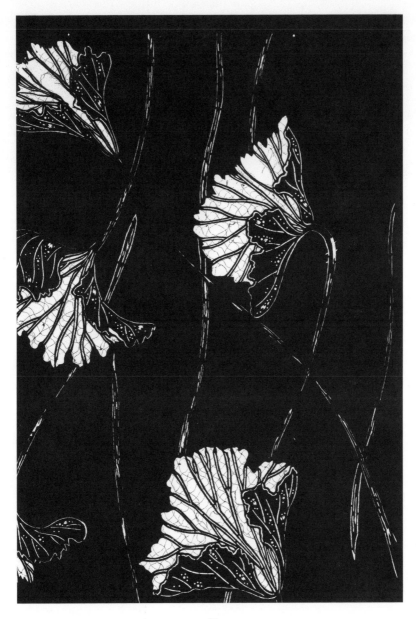

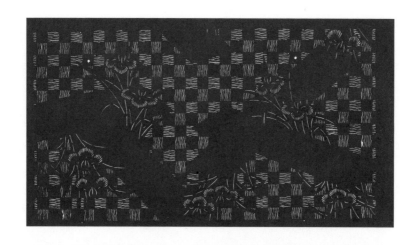

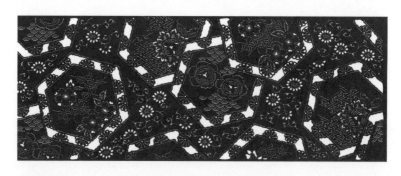

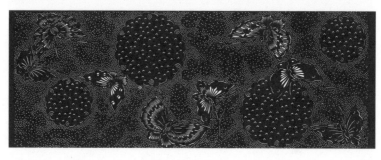

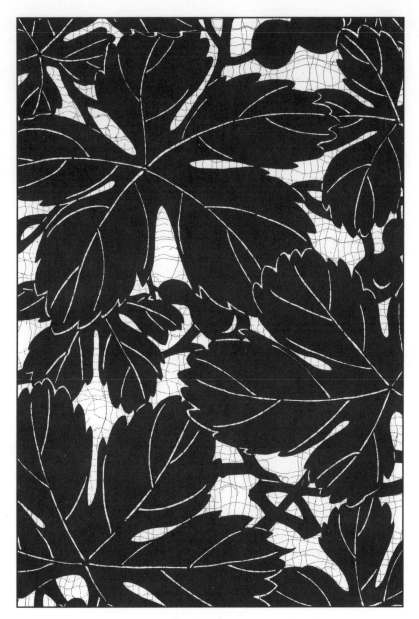

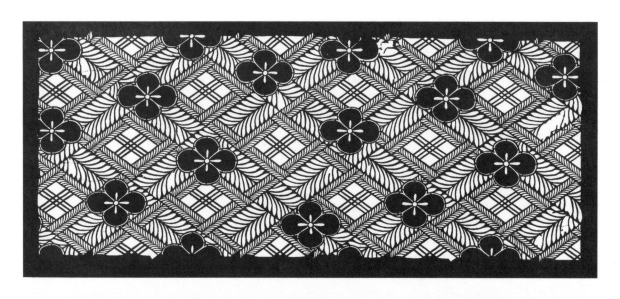

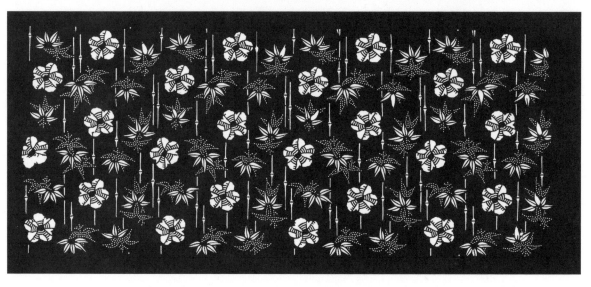

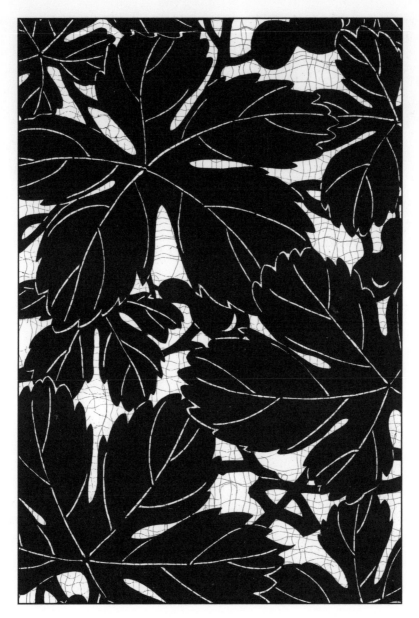

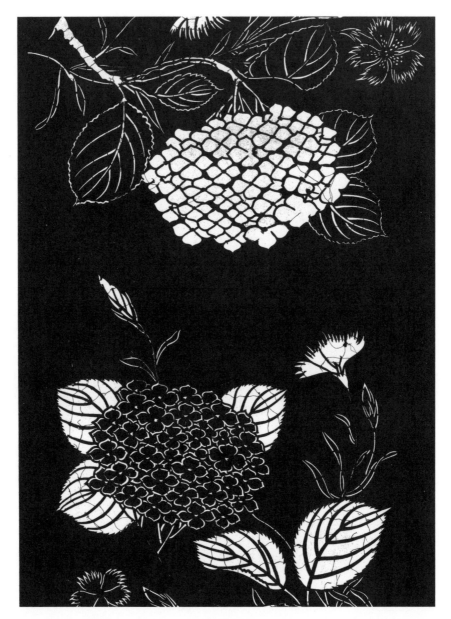

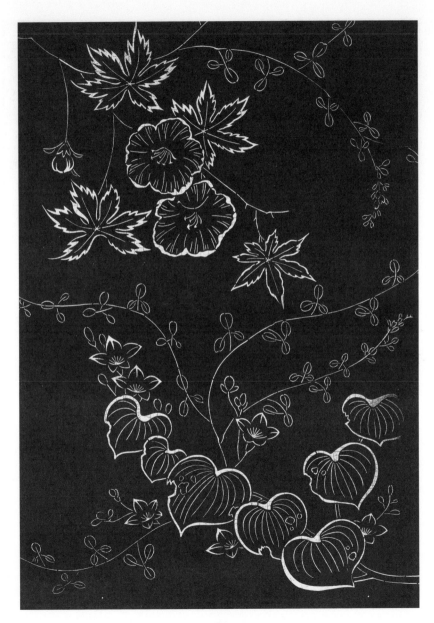

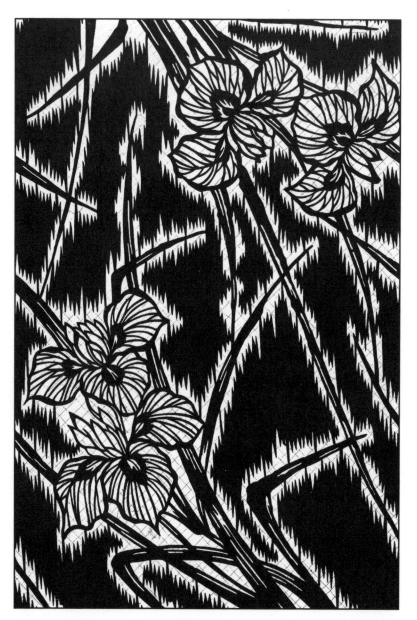

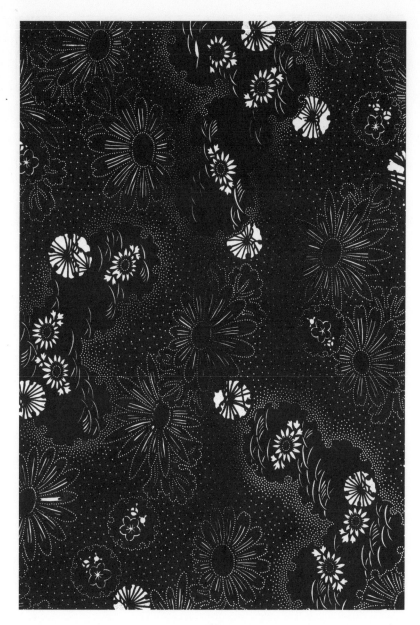

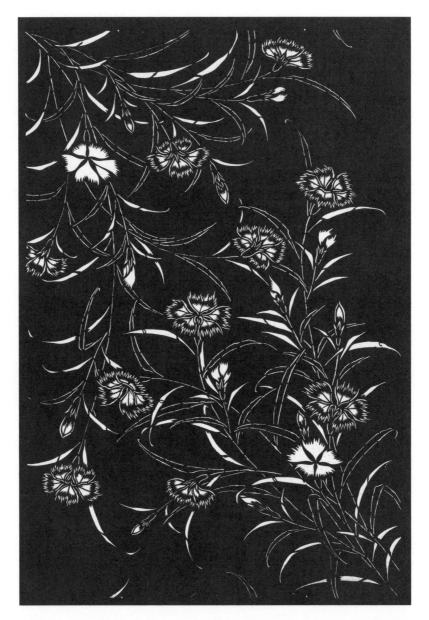

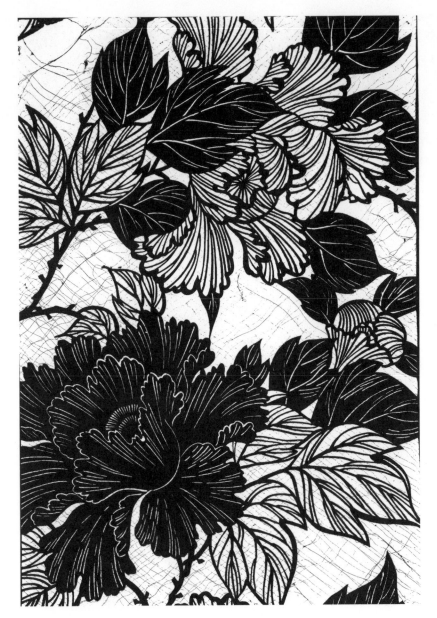

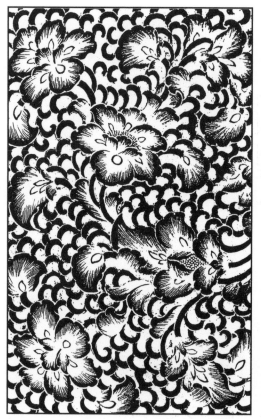 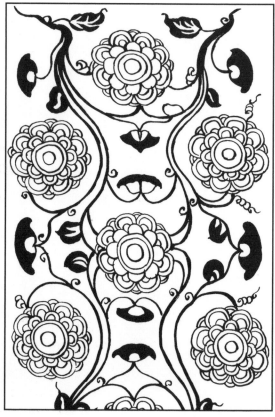

72:
Left: Ibiscus. **Right:** Climbing plant.
À gauche: Hibiscus. **À droite:** Plante grimpante.
Links: Hibiscus. **Rechts:** Kletterplanze.
Izquierda: Majagua. **Derecha:** Planta
trepadora.
Слева: Гибискус. Справа: Вьющееся
растение.

73:
Ibiscus.
Hibiscus.
Majagua.
Гибискус.

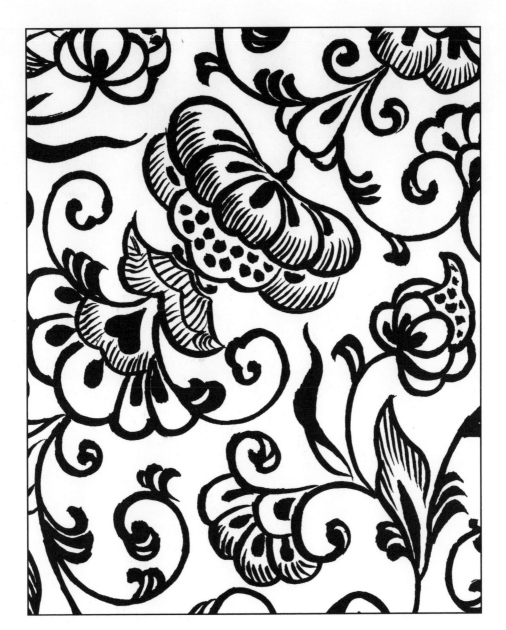

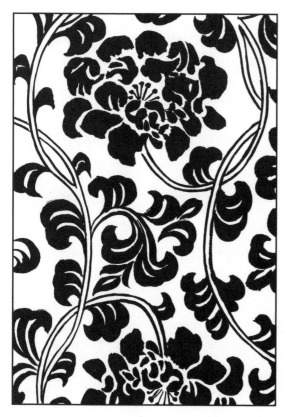

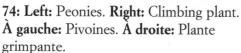

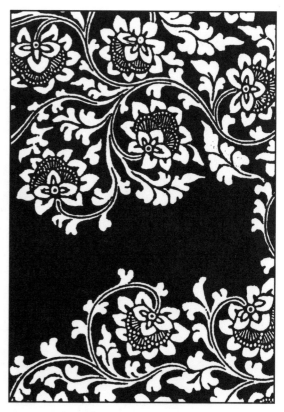

74: Left: Peonies. **Right:** Climbing plant.
À gauche: Pivoines. **À droite:** Plante grimpante.
Links: Bauernrosen. **Rechts:** Kletterplanze.
Izquierda: Peonías. **Derecha:** Planta trepadora.
Слева: Пионы. Справа: Вьющееся растение.

75: Left: Climbing plant. **Right:** Stylized flowers and leaves.
À gauche: Plante grimpante. **À droite:** Fleurs et feuilles stylisées.
Links: Kletterplanze. **Rechts:** Stilisierte Blumen und Blätter.
Izquierda: Planta trepadora. **Derecha:** Flores y hojas estilizadas.
Слева: Вьющееся растение. Справа: Стилизованные цветы и листья.

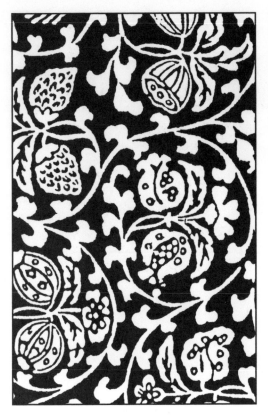

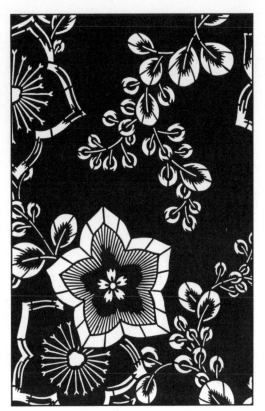

76:
Dandelions.
Pissenlits.
Löwenzahn.
Cardillos.
Одуванчики.

77:
Left: Primroses. **Right:** Chrysantemums.
À gauche: Primevères. **À droite:**
Chrysanthèmes.
Links: Primeln. **Rechts:** Chrysanthemen.
Izquierda: Primaveras. **Derecha:**
Crisantemos.
Слева: Примулы. Справа:
Хризантемы.

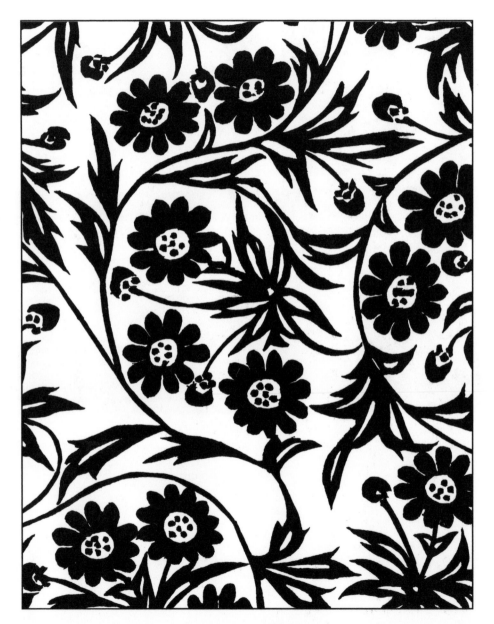

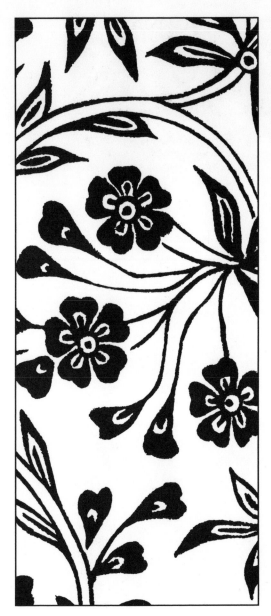
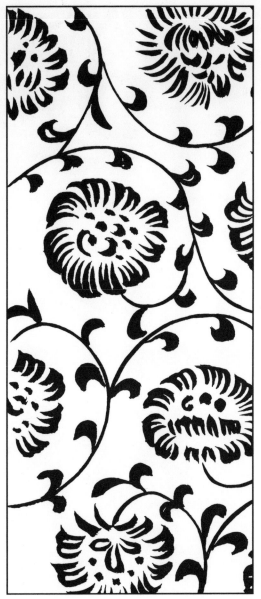

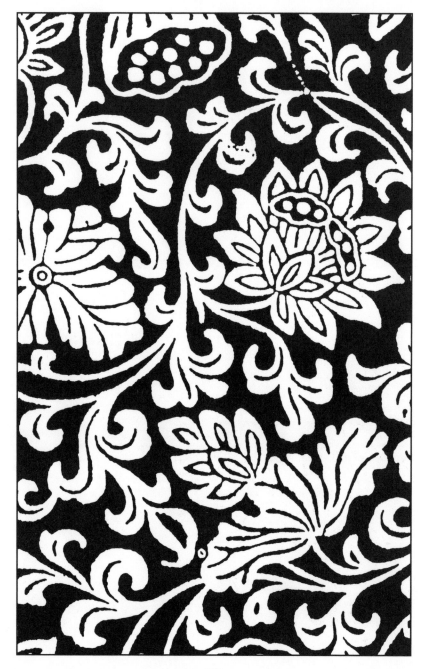

78:
Peonies.
Pivoines.
Bauernrosen
Peonías.
Пионы.

79:
Top: Peonies. **Bottom:** Chrysanthemums.
En haut: Pivoines. **En bas:** Chrysanthèmes.
Oben: Bauernrosen. **Unten:**
Chrysanthemen.
Arriba: Peonías. **Abajo:** Crisantemos.
Наверху: Пионы. Внизу: Хризантемы.

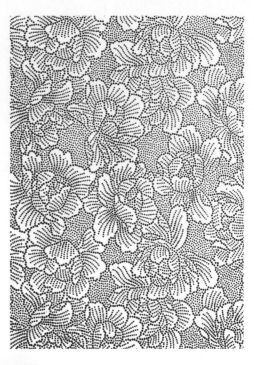

80:
Chrysanthemums.
Chrysanthèmes.
Chrysanthemen.
Crisantemos.
Хризантемы.

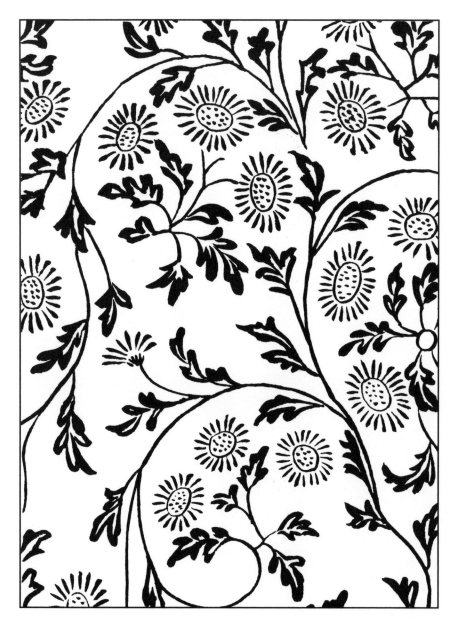

Animals
Animaux
Tiere
Animales
Животные

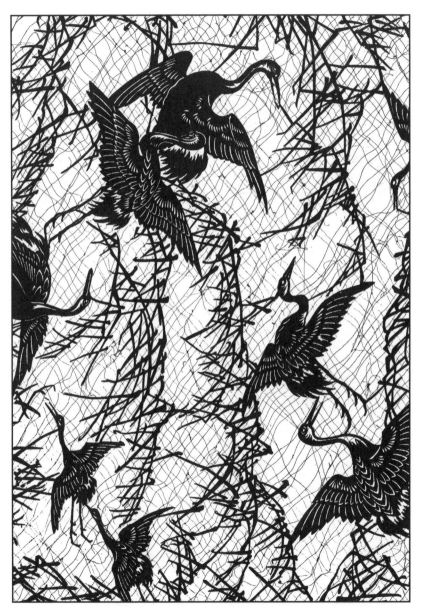

82-84:
*Japanische Motive für
Flaäschenverzierung,*
Verlag der Blätter für
Architektur und
Kunsthandwerk, Berlin,
n.d.

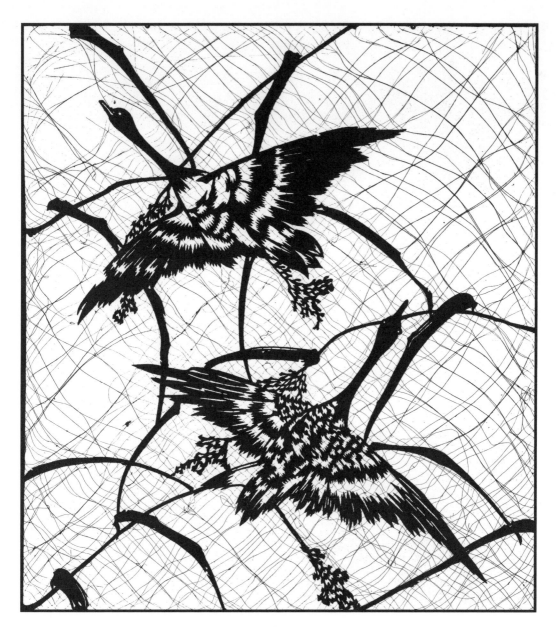

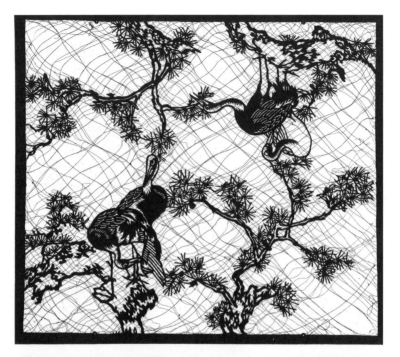

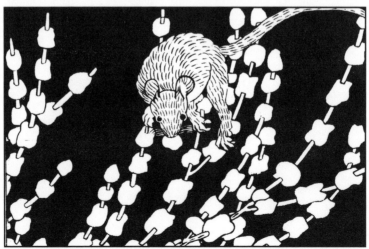

84

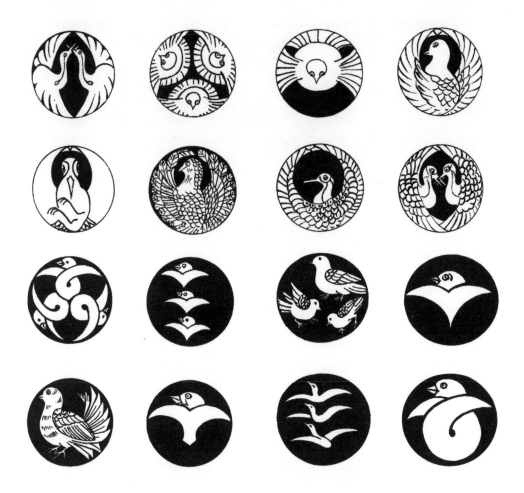

85-86:
Escutcheons.
Écussons.
Wappen.
Escudos.
Орнаментальные щиты.

Thomas W. Cutler. *A Grammar of Japanese Ornament and Design,* London, 1880.

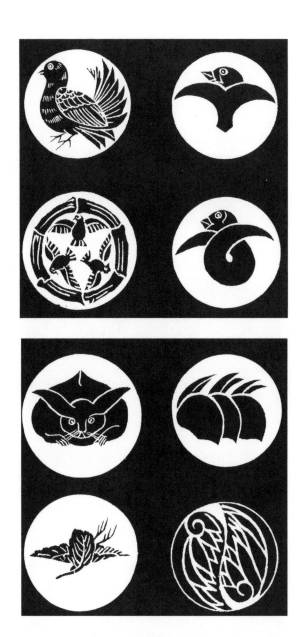

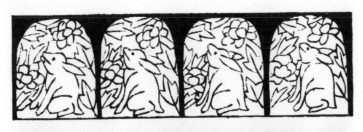

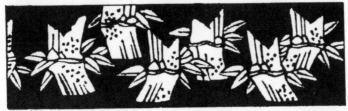

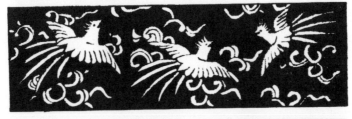

Vignettes, 19th century.
Vignettes, XIXᵉ siècle.
Vignetten, 19. Jh.
Viñetas, siglo XIX.
Виньетки, 19 век.

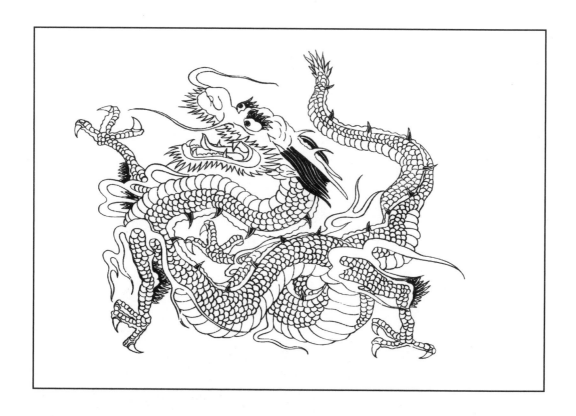

88:
Thomas W. Cutler. *A Grammar of Japanese Ornament and Design,* London, 1880.

89-94:
Japanische Motive für Flaäschenverzierung, Verlag der Blätter für Architektur und Kunsthandwerk, Berlin, n.d.

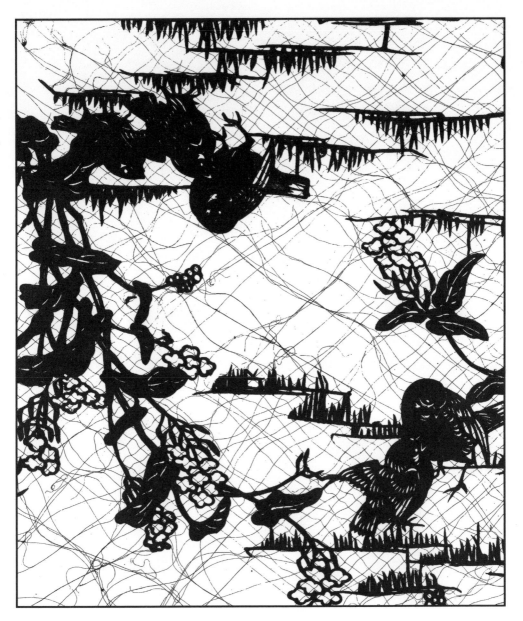

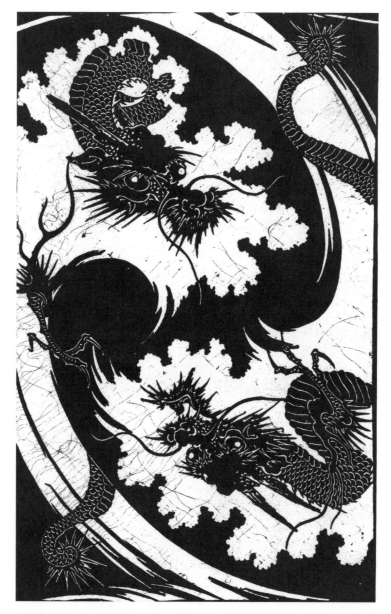

90

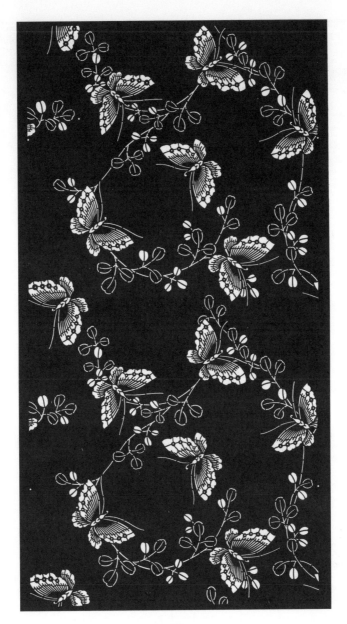

91

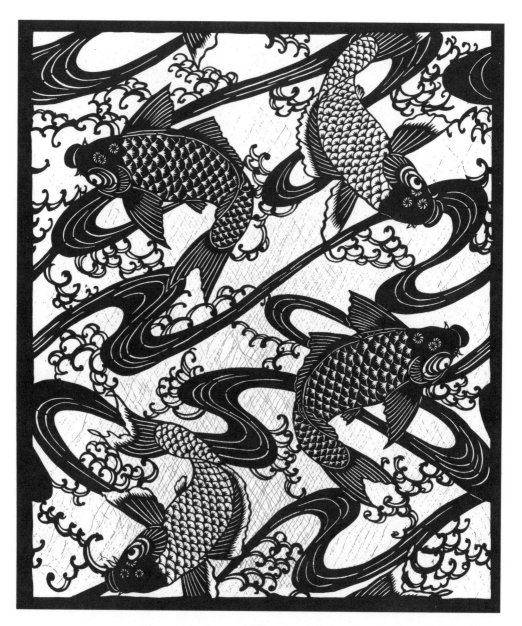

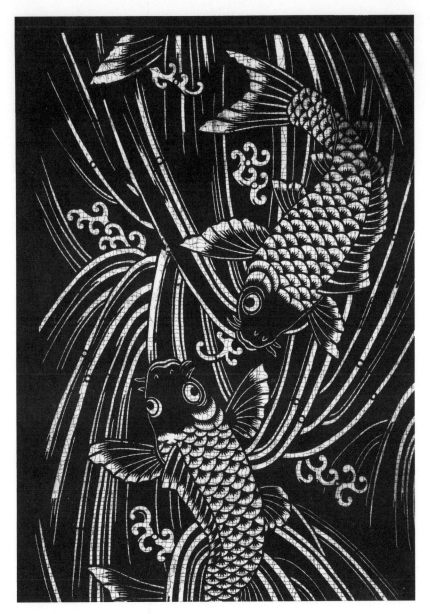

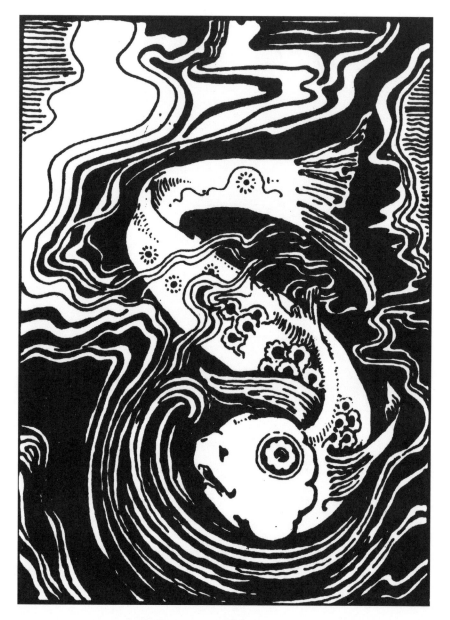

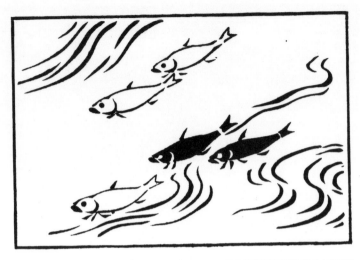

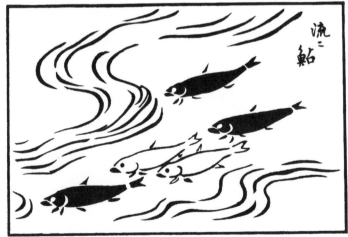

Woodprints, 19th century.
Gravures sur bois, XIX^e siècle.
Holzschnitt, 19. Jh.
Grabados de madera.
Гравюры на дереве, 19 век.

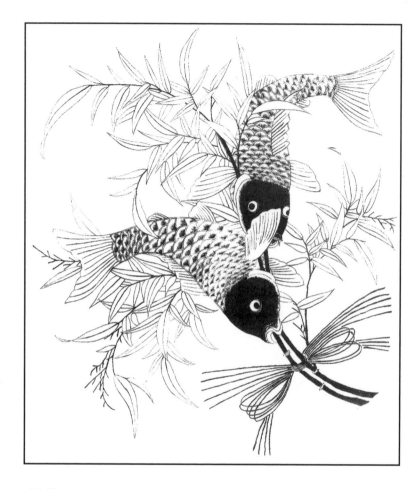

96-98:
Thomas W. Cutler. *A Grammar of Japanese Ornament and Design,* London, 1880.

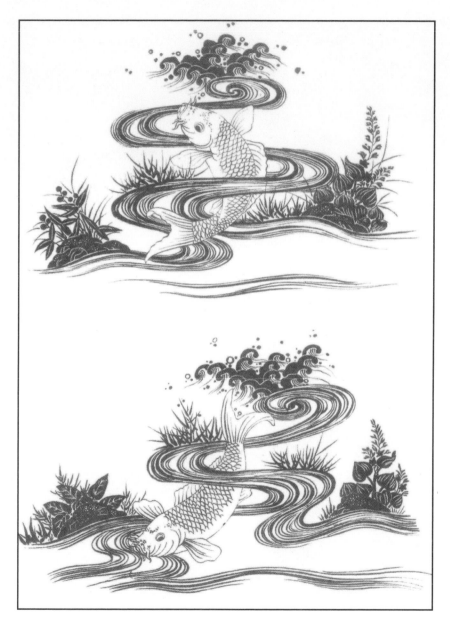

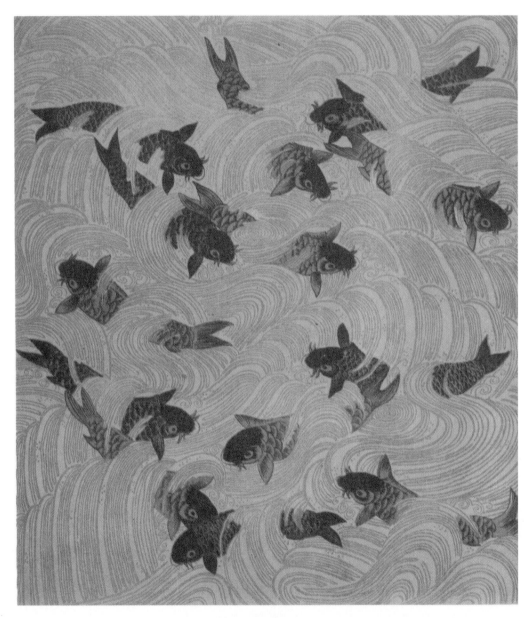

Embroidery.
Broderie.
Stickerei.
Bordado.
Вышивка.

George Ashdown
Audsley, *The Ornamental
Arts of Japan,* London,
1882.

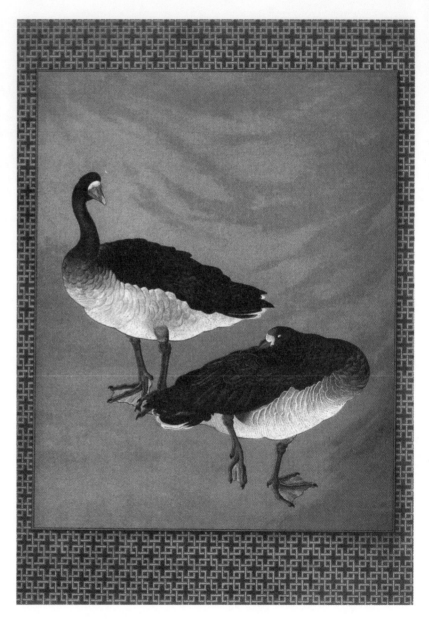

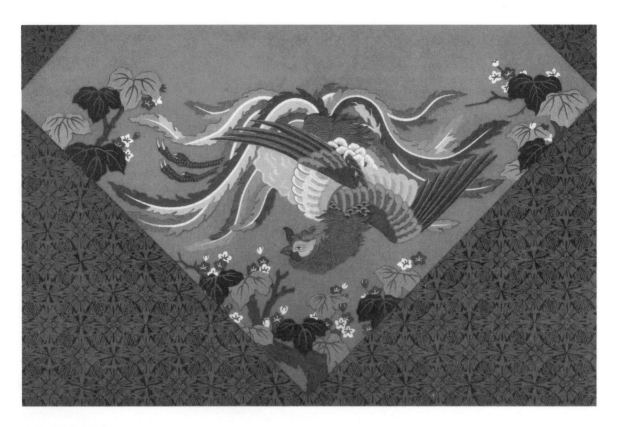

Silk and gold tapestry.
Tapisserie de soie et or.
Wandbehang, Seide und Gold.
Colgadura de seda y oro.
Ирисы, одуванчики, пионы с рыбами, 18 век.

Yoshitoshi, *The Cry of the Fox,* 1886.
Yoshitoshi, *Le Cri du Renard,* 1886.
Yoshitoshi, *Der Schrei des Fuchses,* 1886.
Yoshitoshi, *El Grito del zorro,* 1886.
Йошитоши Крик лисы, 1886.

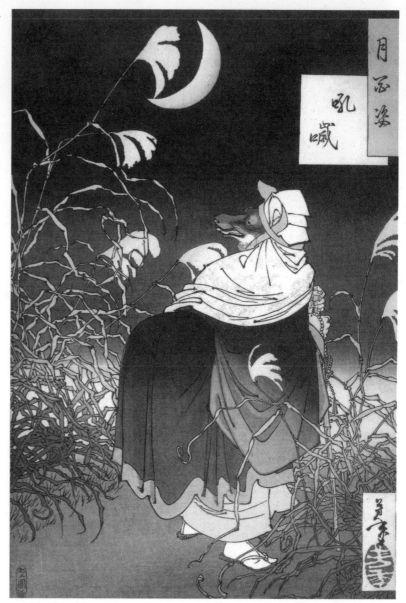

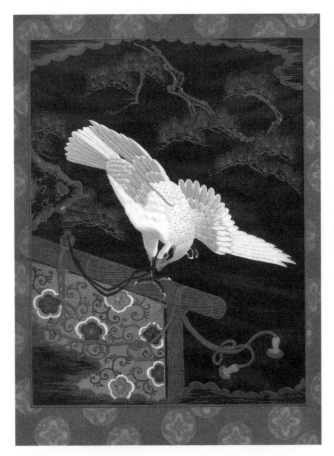

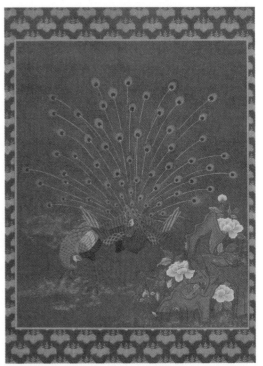

Top: Embroideries. **Bottom:** Stylized cranes.
En haut: Broderies. **En bas:** Grues stylisées.
Oben: Stickereien. **Unten:** Stilisierte Kraniche.
Arriba: Bordados. **Abajo:** Grullas estilizadas.
Наверху: Вышивки. Внизу: Стилизованные
журавли

George Ashdown Audsley, *The Ornamental Arts of Japan,* London, 1882.
Thomas W. Cutler. *A Grammar of Japanese Ornament and Design,* London, 1880.

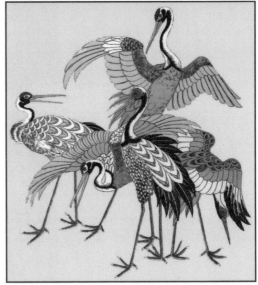

Lacquer.
Laque.
Lack.
Laca.
Рисунок,
покрытый лаком.

George Ashdown
Audsley, *The
Ornamental Arts of
Japan,* London,
1882.

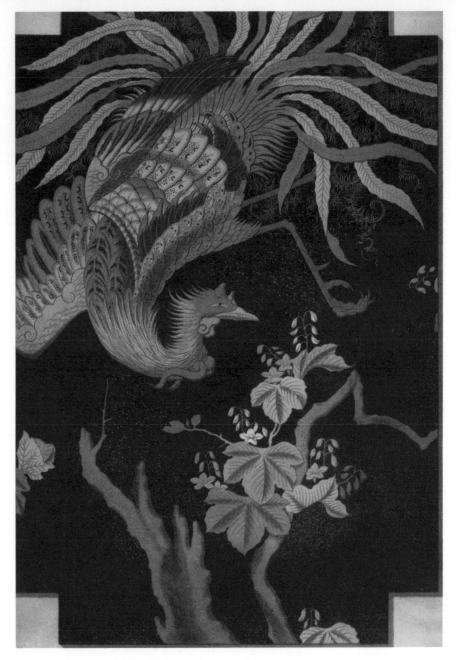

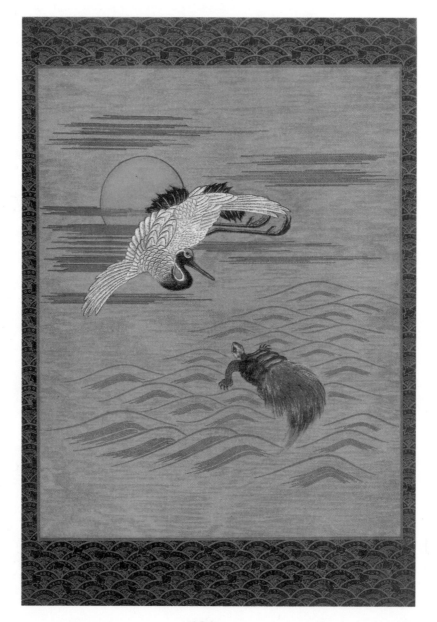

104:
Embroidery.
Broderie.
Bordado.
Вышивка.

George Ashdown Audsley, *The Ornamental Arts of Japan,* London, 1882.

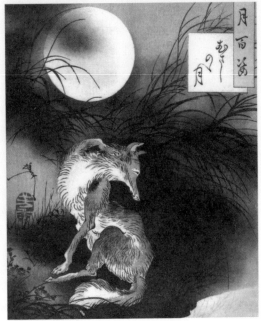

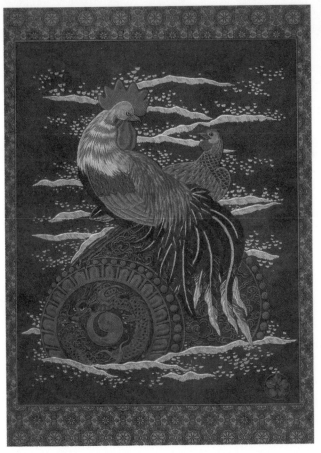

105:
Left: Embroidery.
À gauche: Broderie.
Links: Stickereien.
Izquierda: Bordado.
Слева: Вышивка

George Ashdown Audsley, *The Ornamental Arts of Japan,* London, 1882.

Right: Yoshitoshi, *Musashi Plain Moon,* 1892.
À droite: Yoshitoshi, *La pleine lune de Musashi,* 1892.
Rechts: *Der volle Mond von Musashi,* 1892.
Derecha: Yoshitoshi. *El Plenilunio de Musashi,* 1892.
Справа: Йошитоши Луна Мусаши, 1892.

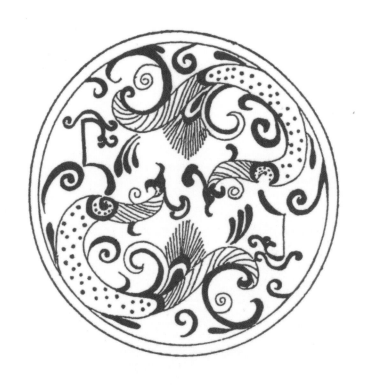

Symetric birds decoration.
Décor symétrique d'oiseaux.
Symmetrischer Vogeldekor.
Decoración simétrica con aves.
Симметричный декор с птицами.

Top: Thomas W. Cutler. *A Grammar of Japanese Ornament and Design,* London, 1880. **Bottom:** Frieze with symetric animals.
En haut: Thomas W. Cutler. *A Grammar of Japanese Ornament and Design,* London, 1880. **En bas:** Frise avec animaux symétriques.
Oben: Thomas W. Cutler. *A Grammar of Japanese Ornament and Design,* London, 1880. **Unten:** Fries mit tymmetrischer Tiere.
Arriba: Thomas W. Cutler. *A Grammar of Japanese Ornament and Design,* London, 1880. **Abajo:** Friso con animales simétricos.
Наверху: Thomas W. Cutler. *A Grammar of Japanese Ornament and Design,* London, 1880. Внизу: Фриз с симметричными животными.

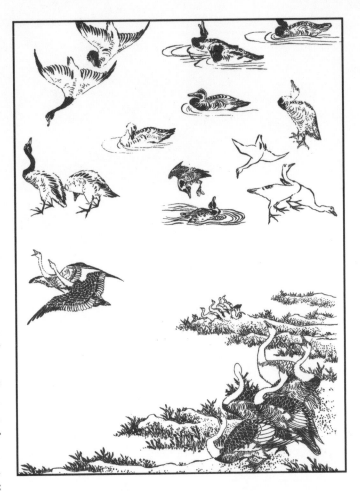

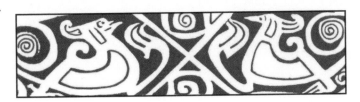

107

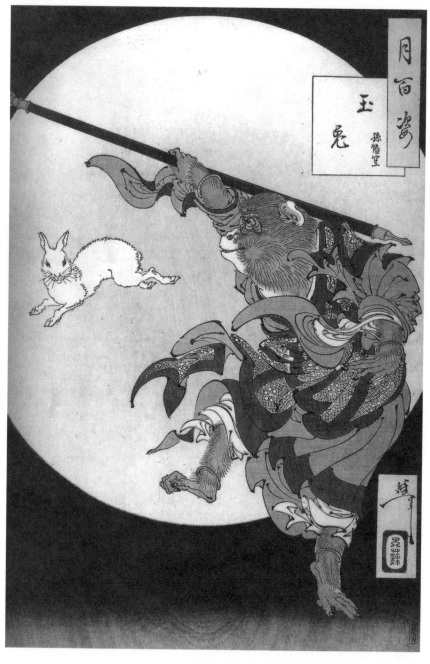

Yoshitoshi, *Jade Rabbit,* 1889.
Yoshitoshi, *Le lapin en jade,* 1889.
Yoshitoshi, *Das Kaninchen aus Jade,* 1889.
Yoshitoshi, *El Conejo de jade,* 1889.
Йошитоши Желтоватый заяц, 1889.

Top:
Painting on silk.
Peinture sur soie.
Seidenmalerei.
Pintura sobre seda.
Наверху: Рисунок на шелке.

Thomas W. Cutler. *A Grammar of Japanese Ornament and Design,* London, 1880.

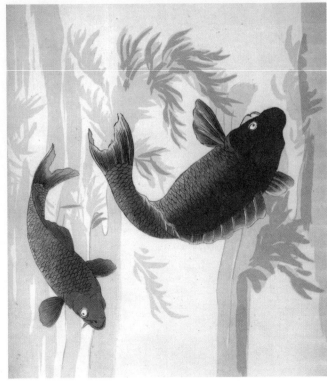

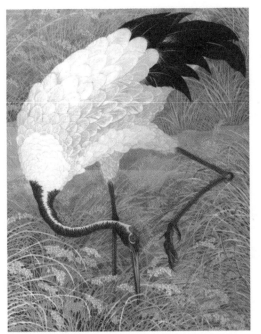

Bottom:
Painting on silk.
Peinture sur soie.
Seidenmalerei.
Pintura sobre seda.
Внизу: Рисунок на шелке.

George Ashdown Audsley,
The Ornamental Arts of Japan,
London, 1882.

Left: Peacock, 1730. **Right:** Hawk.
À gauche: Paon, 1730. **À droite:** Aigle.
Links: Pfau, 1730. **Rechts:** Adler.
Izquierda: Pavón. **Derecha:** Águila, 1710.
Слева: Павлин, Уки·-е, 1730.
Справа: Ястреб, Уки·-е, 1710.

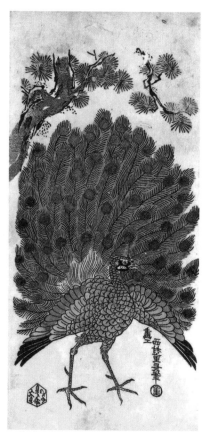

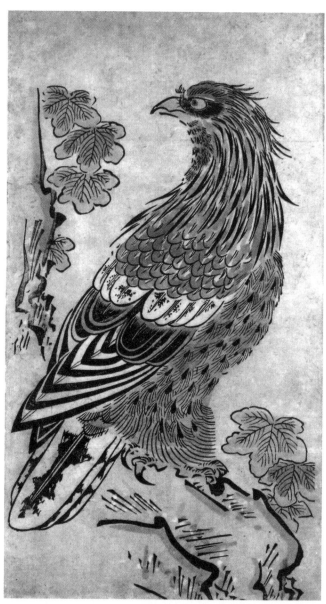

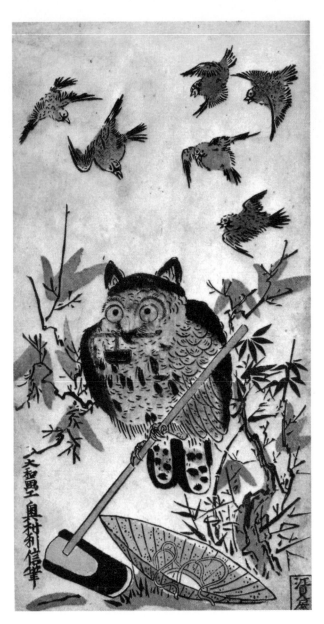

Left: Owl and sparrows, 1730.
Right: Owl, 1830.
À gauche: Hibou et moineaux, 1730. **À droite:** Hibou, 1830.
Links: Eule und Spatzen, 1730.
Rechts: Eule, 1830.
Izquierda: Búho y gorrión, 1730.
Derecha: Búho, 1830.
Слева: Сова и воробьи, Уки·-е, 1730. Справа: Сова, Уки·-е, 1830.

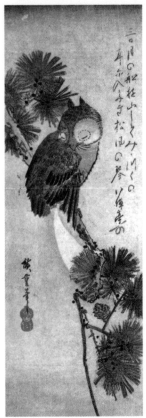

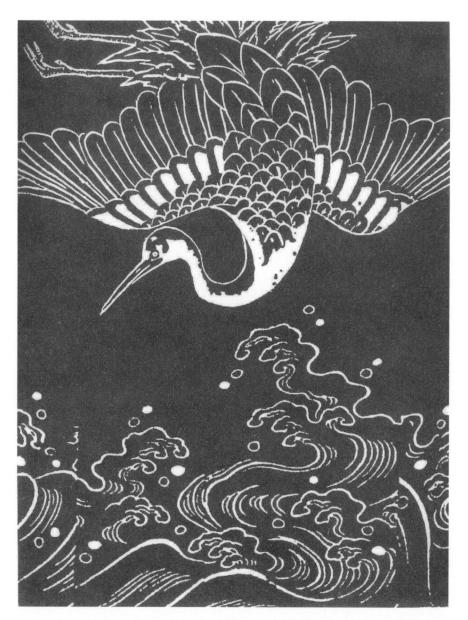

112:

Traditional blue and white pattern.
Motif traditionnel bleu et blanc.
Traditionelles blaues und weißes Muster.
Motivo tradicional azul y blanco.
Традиционный рисунок с сине-белой
росписью.

113:

Top: Grapevines and birds. **Bottom:**
Swallow.
En haut: Plantes grimpantes et oiseaux.
En bas: Hirondelle.
Oben: Kletterplanze und Vögel. **Unten:**
Schwalbe.
Arriba: Plantas trepadoras y aves. **Abajo:**
Golondrina.
Наверху: Виноградные лозы с
птицами. Внизу: Ласточка.

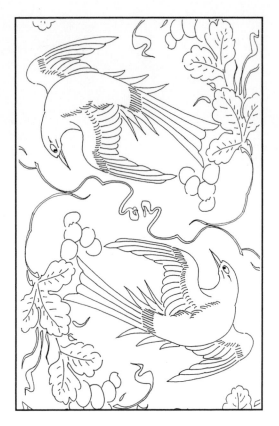

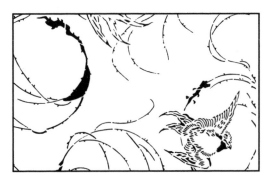

114:
Top: Bats and gourds. **Bottom:** Water birds.
En haut: Chauves-souris et coloquintes.
En bas: Oiseaux aquatiques.
Oben: Fledermäuse und Koloquinte.
Unten: Wasservögel.
Arriba: Murciélagos y coloquíntidas.
Abajo: Aves acuáticos.
Наверху: летучие мыши с тыквами.
Внизу: Водоплавающие птицы.

115:
Wild ducks and gooses.
Canards et oies sauvages.
Wilde Enten und Gänse.
Patos y gansos salvajes.
Дикие утки и гуси.

Thomas W. Cutler. *A Grammar of Japanese Ornament and Design,* London, 1880.

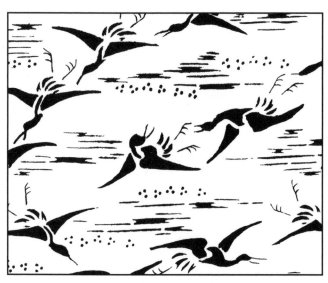

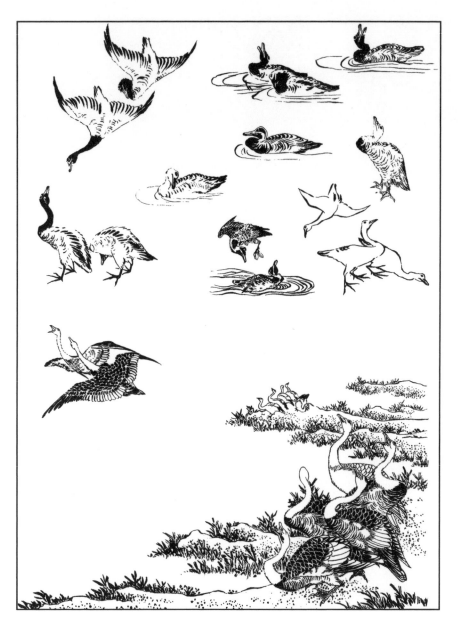

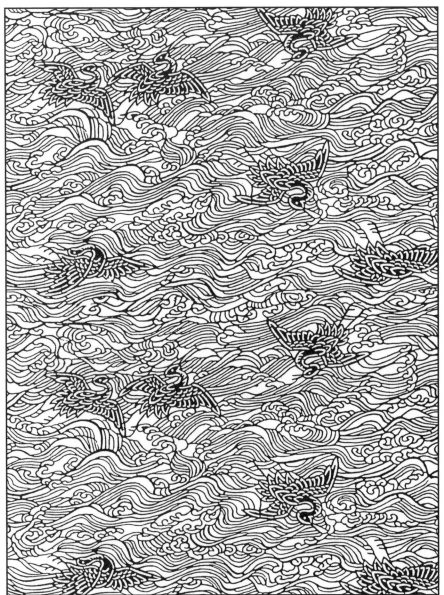

Birds and waves.
Oiseaux et vagues.
Vögel und Wellen.
Aves y olas.
Птицы на волнах.

Butterflies.
Papillons.
Schmetterlinge.
Mariposas.
Бабочки.

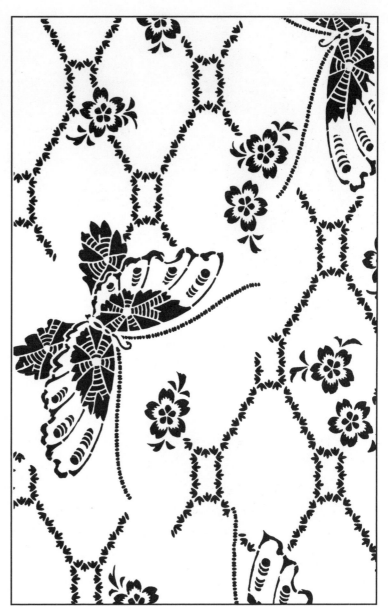

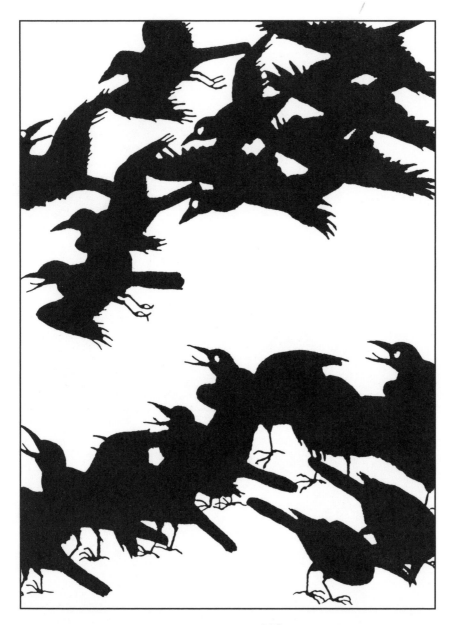

118:
Crows.
Corbeaux.
Raben.
Cuervos.
Вороны.

119:
Rabbits.
Lapins.
Kaninchen.
Conejos.
Зайцы.

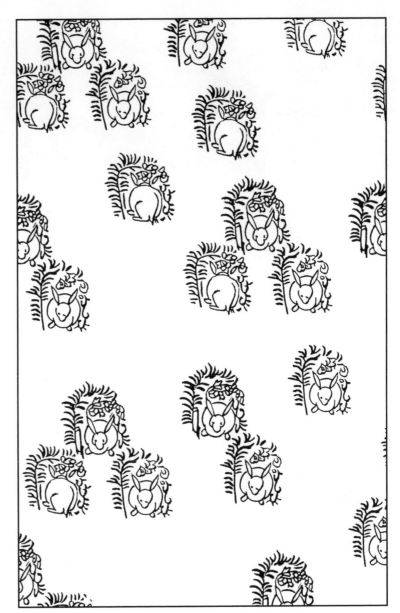

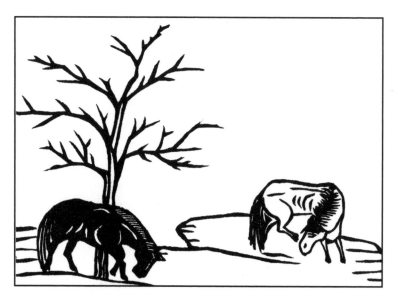

Top: Horses. **Bottom:** Birds and flowers.
En haut: Chevaux. **En bas:** Oiseaux et fleurs.
Oben: Pferde. **Unten:** Vögel und Blumen.
Arriba: Caballos. **Abajo:** Aves y flores.
Наверху: Лошади.
Внизу: Птицы с цветами.

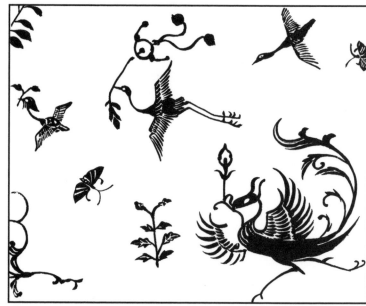

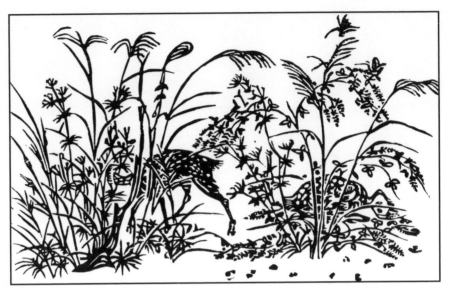

Deers.
Daims.
Damhirsch.
Gamos.
Лани.

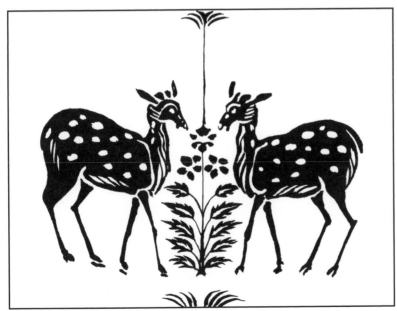

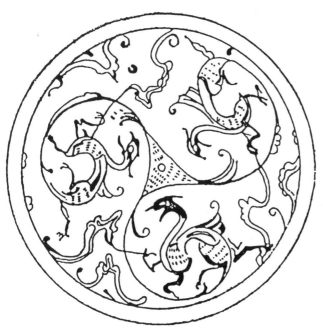

Stylized dragons.
Dragons stylisés.
Stilisierte Drachen.
Dragones estilizados.
Стилизованные драконы.

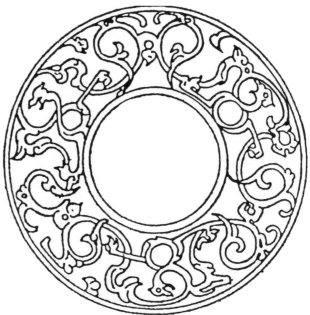

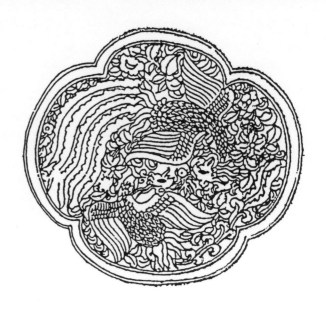

Stylized phoenixes.
Phénix stylisés.
Stilisierte Phönix.
Fénix estilizados.
Стилизованные фениксы.

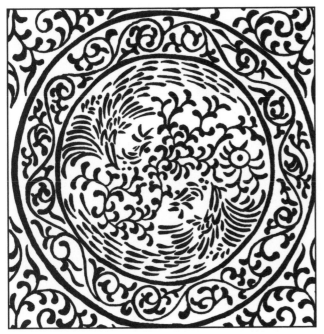

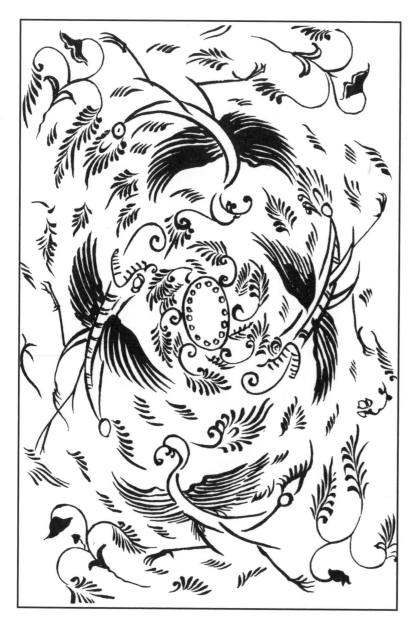

124:
Phoenixes and plants.
Phénix et plantes.
Phönix und Pflanzen.
Fénix y plantas.
Фениксы с растениями.

125:
Butterflies.
Papillons.
Schmetterlinge.
Mariposas.
Бабочки.

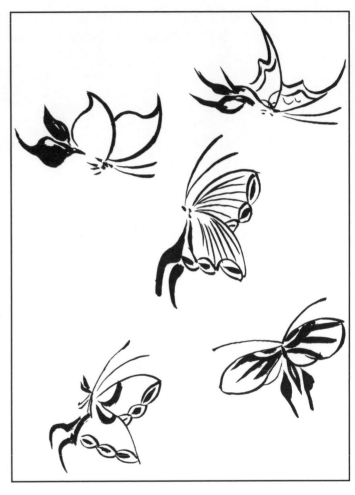

Peacock.
Paon.
Pfau.
Павлин.

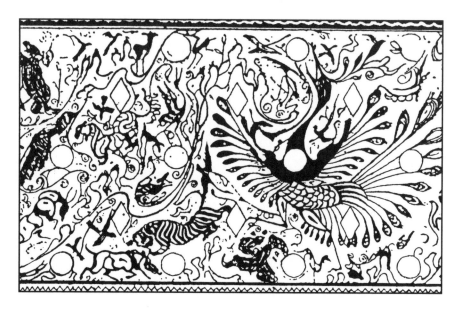

126:
Peacock and dragoons.
Paon et dragons.
Pfau und Drachen.
Pavón y dragones.
Павлин с драконами.

127:
Top: Rabbits, birds and tiger.
Bottom: Elephant, bear, deers, birds and dragoons.
En haut: Lapins, oiseaux et tigre.
En bas: Éléphant, ours, daims, oiseaux et dragons.
Oben: Kaninchen, Vögel und Tiger. **Unten:** Elefant, Bären, Damhirsch, Vögel und Drachen.
Arriba: Conejos, aves y tigre.
Abajo: Elefante, oso, gamos, aves y dragones.
Наверху: Зайцы, птицы и тигр.
Внизу: Слон, медведь, лани, птицы и драконы.

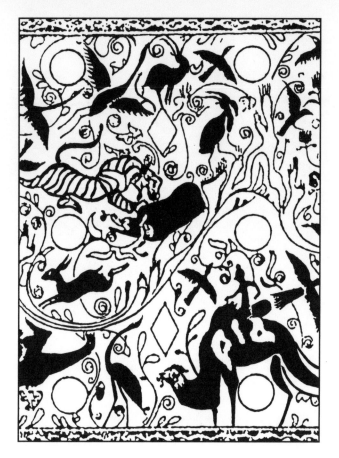

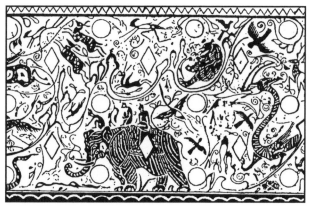

127

Flowers and Phoenixes.
Fleurs et phénix.
Blumen und Phönix.
Flores y fénix.
Цветы с фениксами.

Figures
Personnages
Figuren
Personajes
Персонажи

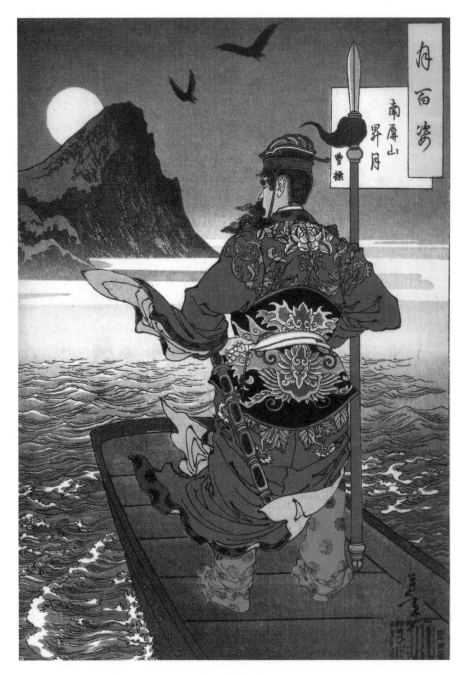

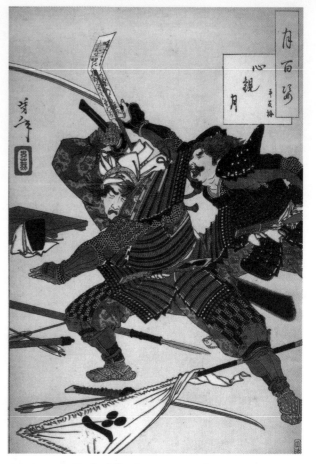

130-144: Yoshitoshi. *One hundred Aspects of the Moon/Cent vues de la lune/Hundert Ansichten des Mondes/Cien caras de la luna,* 1885-1892.
Йошитоши Сто фаз Луны, 1885-1892.

130: 1885: *Rising moon over Mount Nanping.*
Lever de lune sur le mont Nanping.
Von Mond auf dem Berg Nanping aufheben.
Aparición de la luna sobre el monte Nanping.
Восходящая луна над горой Нанпин.

131: 1885: **Left:** *The Forty-seven Ronin.* 1886:
Right: *The moon's inner vision.*
Gauche: *Les 47 Ronin.* **Droite:** *Vision intérieure de la lune.*
Links: *Den sieben und vierzig Ronin.* **Rechts:** *Der innere Anblick des Mondes.*
Izquierda: *Los 47 Ronin.* **Derecha:** *Visión interior de la luna.*
Слева: Сорок семь Ронин. Справа: Внутреннее зрение Луны.

Yoshitoshi. *Goro Tokimune*, 1885.

Shosho Yoshitaka, 1888.

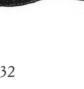

1887: *Goseshi no myobu.*

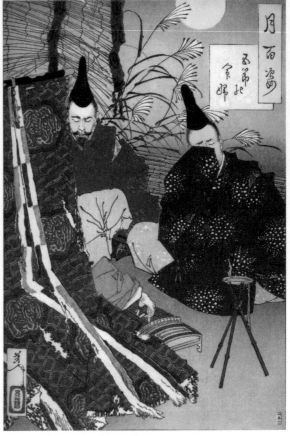

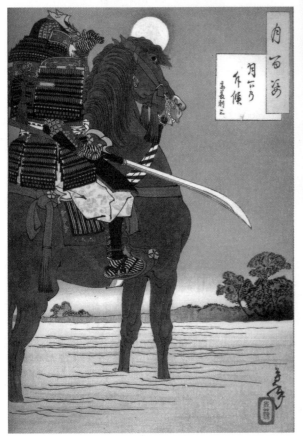

1887: *Moonlight reconnoitering patrol.*
Patrouille de reconnaissance au clair de lune.
Anerkennungskontrollgang am Mondlicht.
Patrulla de reconocimiento en el claro de luna.

134: 1889: **Left:** *Shinobugaoka Moon.* **Right:**
The Forty-seven Ronin.
À gauche: *La Lune de Shinobugaoka.* **À droite:**
Les 47 Ronin.
Links: *Mond von Shinobugaoka.*
Rechts: *Den sieben und vierzig Ronin*
Izquierda: *La Luna de Shinobugaoka.* **Derecha:**
Los 47 Ronin.
Слева: Луна Шинобугаока. Справа: Сорок
семь Ронин.

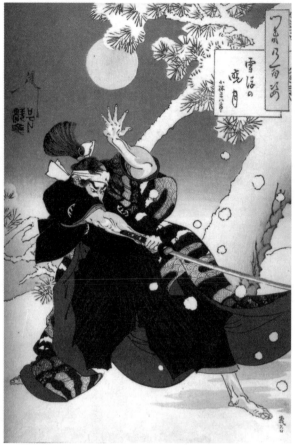

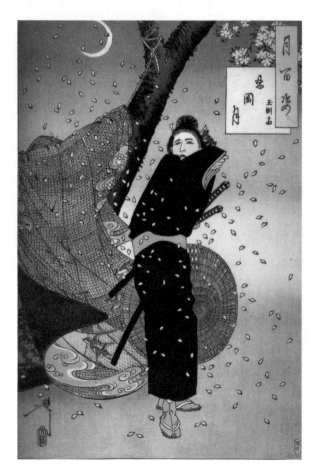

135: 1890/1889: **Left:** *Taira no Tadanori.* **Right:**
The poetess Chiyo.
À gauche: *Taira no Tadanori.* **À droite:** *La
poétesse Chiyo.*
Links: *Taira no Tadanori.* **Rechts:** *Die Poetin
Chiyo.*
Izquierda: *Taira no Tadanori.* **Derecha:** *La
Poetisa Chiyo.*
Слева: Тайрано Таданори. Справа:
Поэтесса Хи·.

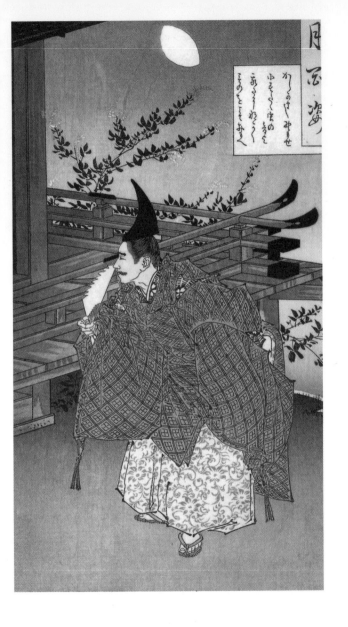

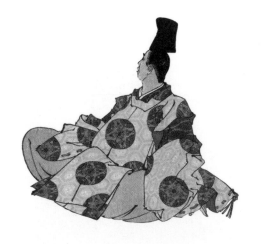

136: 1886/1889: **Top:** *The poet Tsunenobu.* **Bottom:** *Moon and smoke.*
En haut: *Le Poète Tsunenobu.* **En bas:** *Lune et fumée.*
Oben: *Der Dichter Tsunenobu.* **Unten:** *Monde und Rauch.*
Arriba: *El poeta Tsunenobu.* **Abajo:** *Luna y humo.*
Наверху: Поэт
Цуненобу. Внизу: Луна и дым.

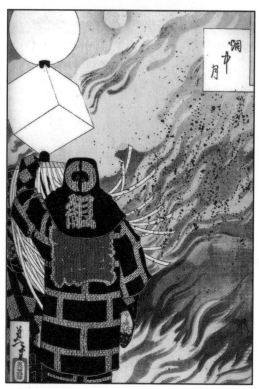

137: 1886/1886/1889: **Left:** *The poetess Ono no Komachi.* **Top right:** *The moon of Yamaki mansion.* **Bottom right:** *Suzaku Gate moon.*
À gauche: *La poétesse Ono no Komachi.* **En haut à droite:** *La Lune de la maison Yamaki.* **En bas, à droite:** *La Lune de la porte de Suzaku.*
Links: *Die Poetin Ono no Komachi.* **Oben, rechts:** *Der Mond der Villa Yamaki.* **Unten, rechst:** *Gattermond Suzaku.*
Izquierda: *La Poetisa Ono no Komachi.* **Arriba, derecha:** *La Luna de la casa Yamaki.* **Abajo, derecha:** *La Luna de la puerta de Suzaku.*
Слева: Поэтесса. Ононо Комахи..
Наверху справа: Луна над дворцом Ямаки. Внизу справа: Справа: Сузаки Гэйт луна.

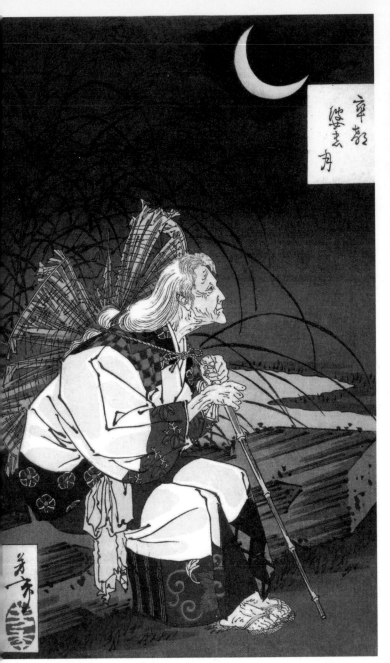

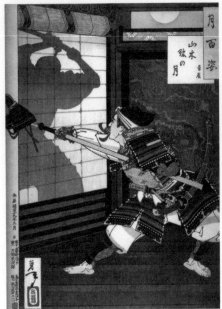

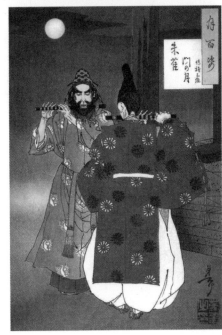

137

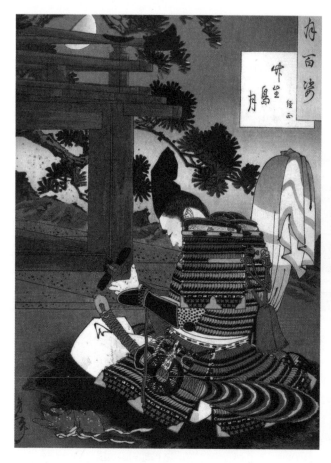

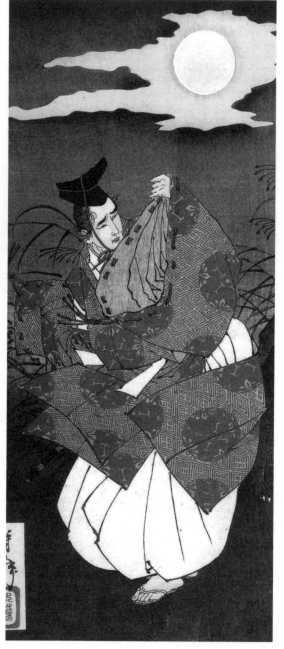

1886: **Left:** *Chibukushima moon.* **Right:** *Kitayama moon.*
À gauche: *La Lune de Chibukushima.* **À droite:** *La Lune de Kitayama.*
Links: *Mond von Chibukushima.* **Right:** *Mond von Kitayama.*
Izquierda: *La Luna de Chibukushima.* **Derecha:** *La Luna de Kitayama.*
Слева: Луна Чибукушима. Справа: Луна Китаяма.

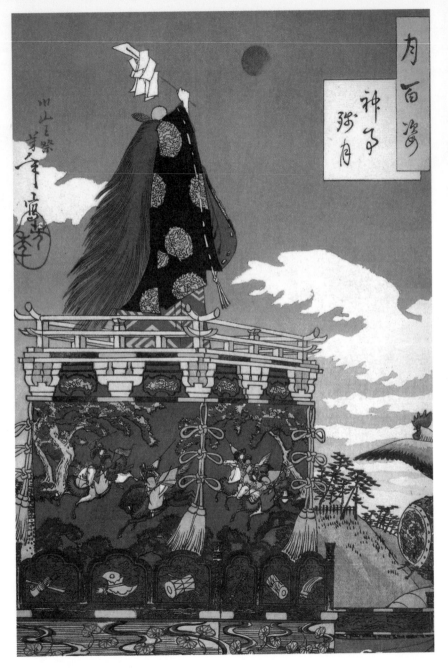

1886: *Shinto rites on a hill.*
Shinto Kirchenbrau auf einem Hügel.
Ritos sintoístas sobre una colina.
Обряды синто на холме.

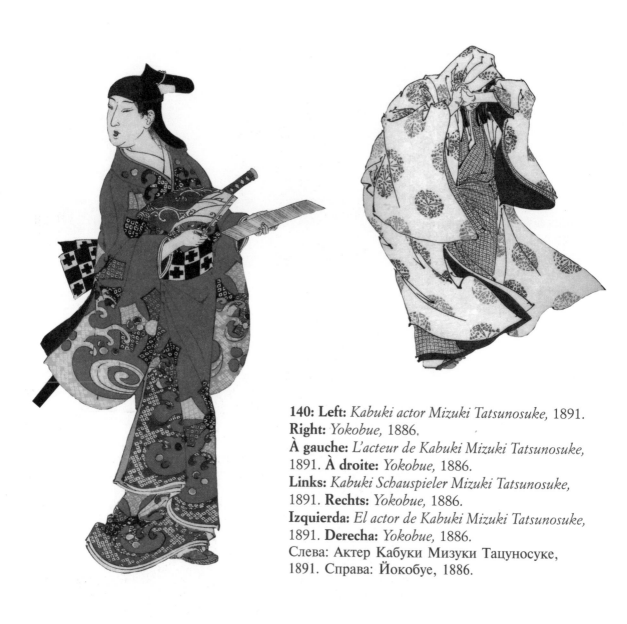

140: Left: *Kabuki actor Mizuki Tatsunosuke,* 1891.
Right: *Yokobue,* 1886.
À gauche: *L'acteur de Kabuki Mizuki Tatsunosuke,*
1891. **À droite:** *Yokobue,* 1886.
Links: *Kabuki Schauspieler Mizuki Tatsunosuke,*
1891. **Rechts:** *Yokobue,* 1886.
Izquierda: *El actor de Kabuki Mizuki Tatsunosuke,*
1891. **Derecha:** *Yokobue,* 1886.
Слева: Актер Кабуки Мизуки Тацуносуке,
1891. Справа: Йокобуе, 1886.

Ariko no Naishi, 1886.

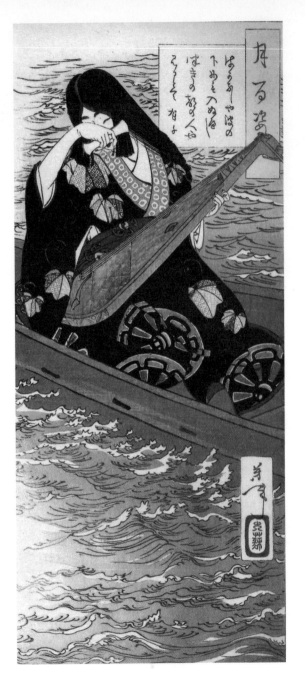

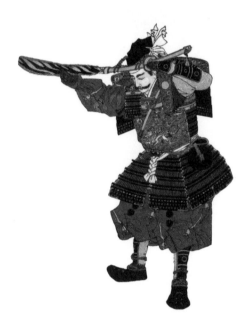

Nitta no Yoshisada, 1886.

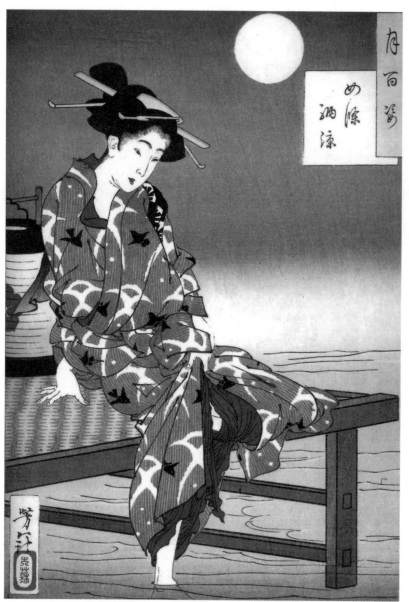

142: *Moonlight at Shijo riverbank,* 1885.

Clair de lune au bord du Shijo, 1885.
Monde am Shijo riverbank, 1885.
Claro de luna en las orillas del Shijo, 1885.
Лунный свет над берегом реки Шиджо,1885.

143: Top left: *Lunacy,* 1886.
Bottom left: *Minamoto no Yoshitsune,* 1888. **Right:** *Toda Hanbei Shigeyuki,* 1887.
En haut à gauche: *Folie,* 1886.
En bas à gauche : *Minamoto no Yoshitsune,* 1888. **À droite:** *Toda Hanbei Shigeyuki,* 1887.
Oben links: *Mond,* 1886.
Unten links: *Minamoto no Yoshitsune,* 1888. **Rechts:** *Toda Hanbei Shigeyuki,* 1887.
Arriba, izquierda: *Locura,* 1886. **Abajo, izquierda :** *Minamoto no Yoshitsune,* 1888. **Derecha:** *Toda Hanbei Shigeyuki,* 1887.
Наверху слева: Лунатизм, 1886. Внизу слева: Минамотоно Йошицуне, 1888. Справа: Тода Ханбей Шигеюки, 1887.

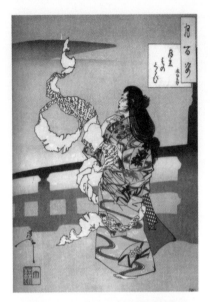

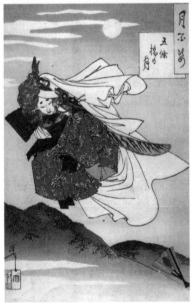

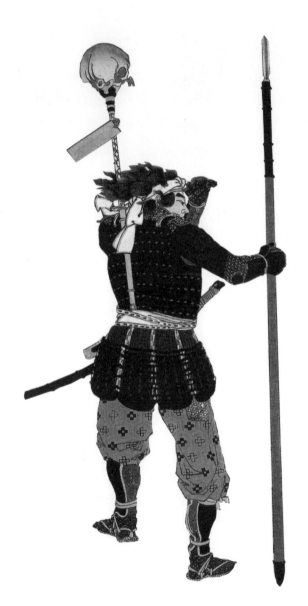

143

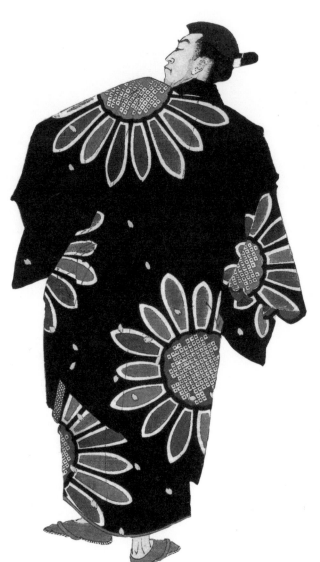

Fukami Jikyu, 1887.

Nature
Natur
Naturaleza
Природа

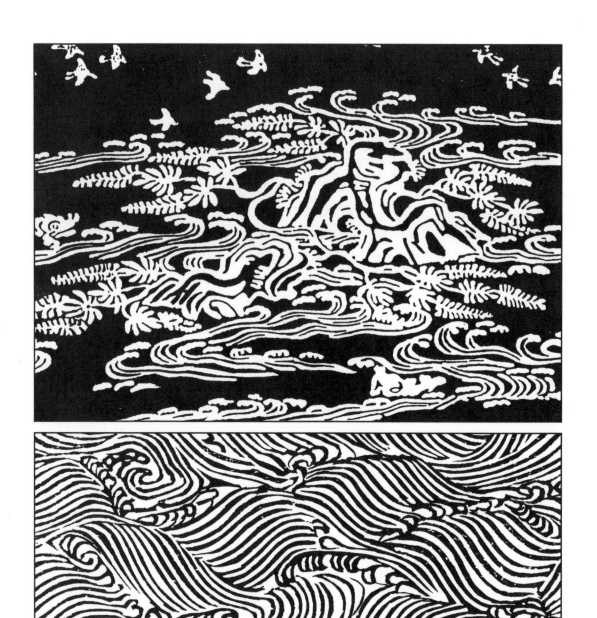

146

146: Top: Island, waves and birds. **Bottom:** Waves and fish.
En haut: Île, vagues et oiseaux. **En bas:** Vagues et poisson.
Oben: Insel, Wellen und Vögel. **Unten:** Wellen und Fisch.
Arriba: Isla, olas y aves. **Abajo:** Olas y pescados.
Наверху: Остров, волны и птицы.
Внизу: Рыба в волнах.

147: Waves.
Vagues.
Wellen.
Olas.
Волны.

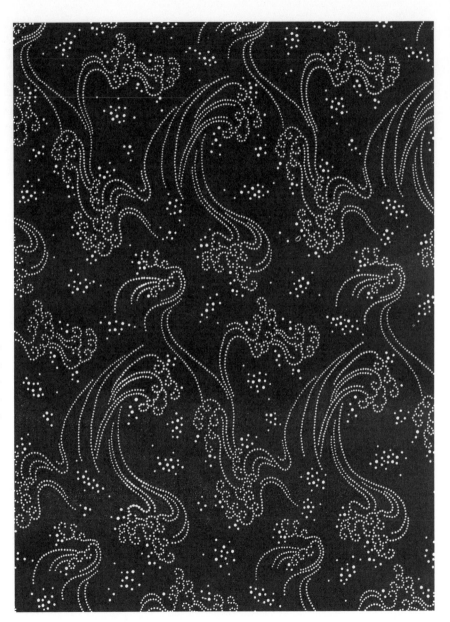

147

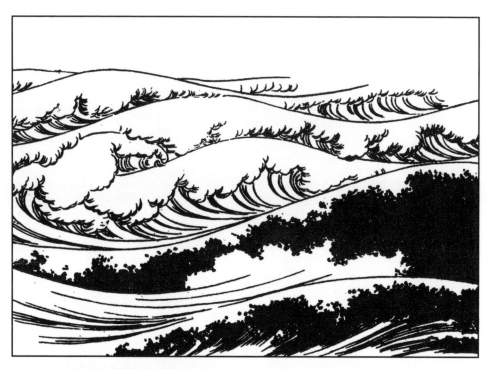

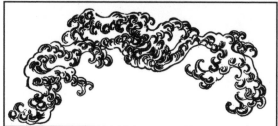

148-149: Thomas W. Cutler, *A Grammar of Japanese Ornament ans Design,* London, 1880.

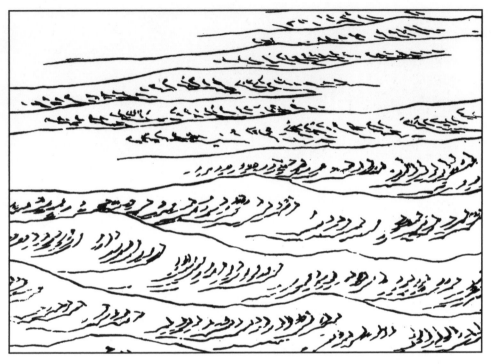

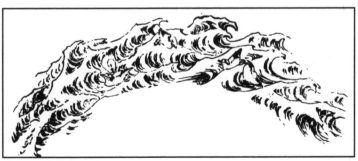

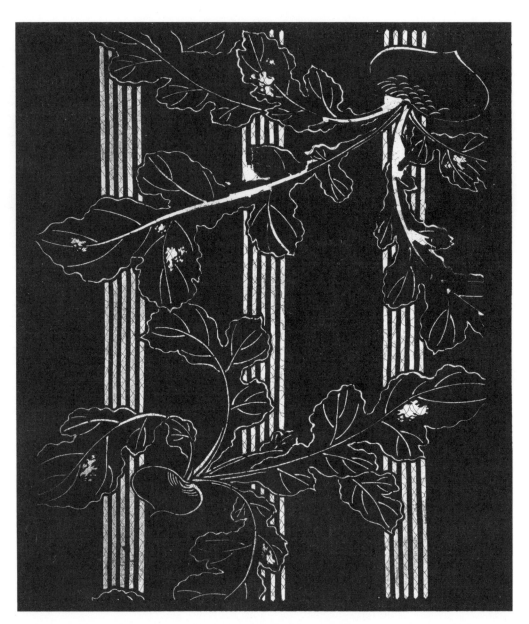

150

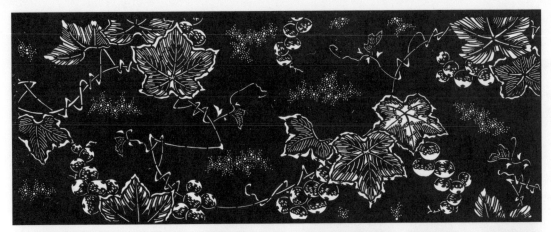

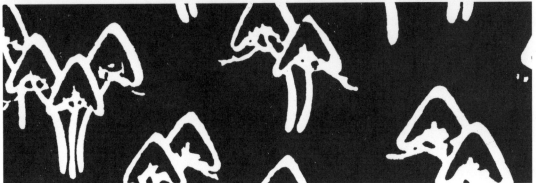

150: *Japanische Motive für Flaäschenverzierung,* Verlag der Blätter für Architektur und Kunsthandwerk, Berlin, n.d.

151: Top: *Japanische Motive für Flaäschenverzierung,* Verlag der Blätter für Architektur und Kunsthandwerk, Berlin, n.d.
Bottom: Trees.
En haut: *Japanische Motive für Flaäschenverzierung,* Verlag der Blätter für Architektur und Kunsthandwerk, Berlin, n.d.
En bas: Arbres.

Oben: *Japanische Motive für Flaäschenverzierung,* Verlag der Blätter für Architektur und Kunsthandwerk, Berlin, n.d.
Unten: Bäume.
Arriba: *Japanische Motive für Flaäschenverzierung,* Verlag der Blätter für Architektur und Kunsthandwerk, Berlin, n.d.
Abajo: Árboles.
Наверху: Japanische Motive fur Flaaschenverzierung, Verlag der Blatter fur Architektur und Kunsthandwerk, Berlin, n.d. Внизу: Деревья.

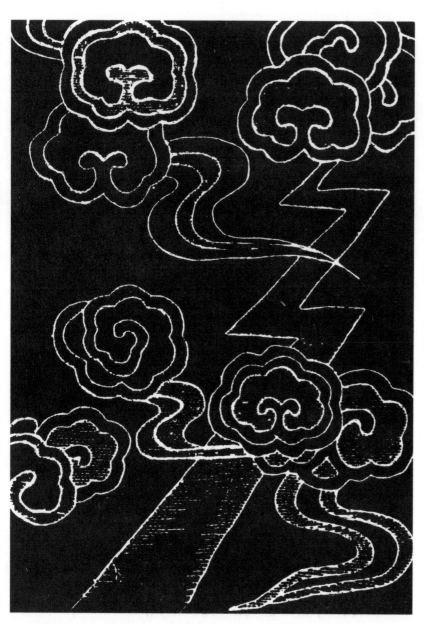

Storm.
Orage.
Gewitter.
Tormenta.
Буря.

Moon and trees.
Lune et arbres.
Mond und Bäume.
Luna y árboles.
Луна и деревья.

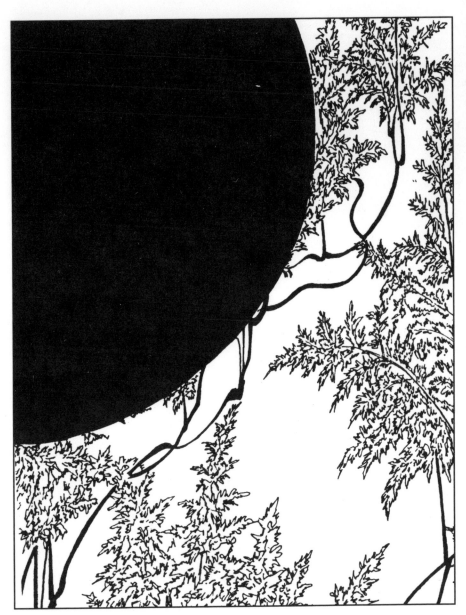

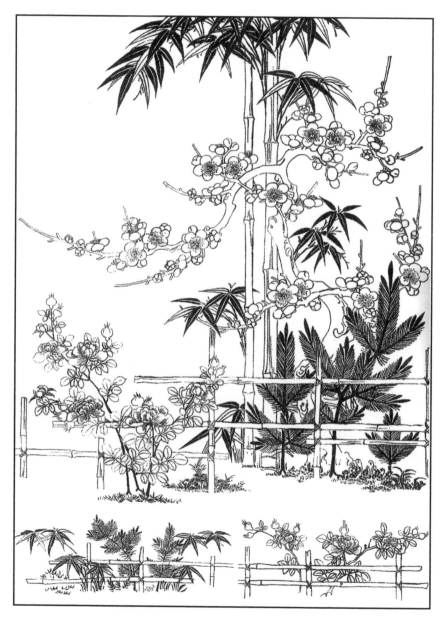

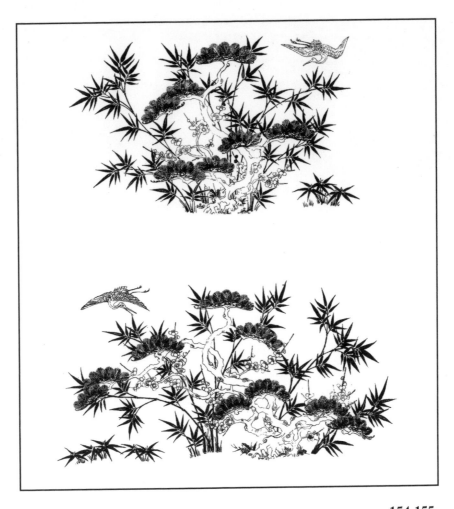

154-155:
Thomas W. Cutler, *A Grammar of Japanese Ornament and Design,*
London, 1880.

155

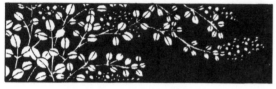

156:
Friezes.
Frises.
Friese.
Frisos.
Фризы.

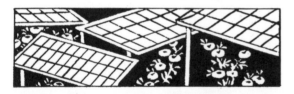

157:
Thomas W. Cutler, *A Grammar
of Japanese Ornament and
Design*, London, 1880.

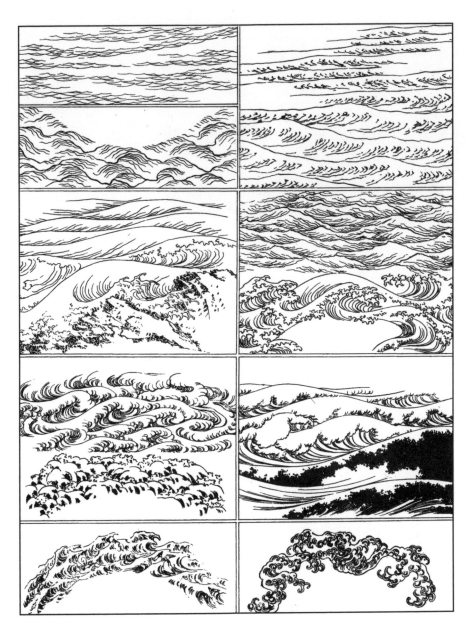

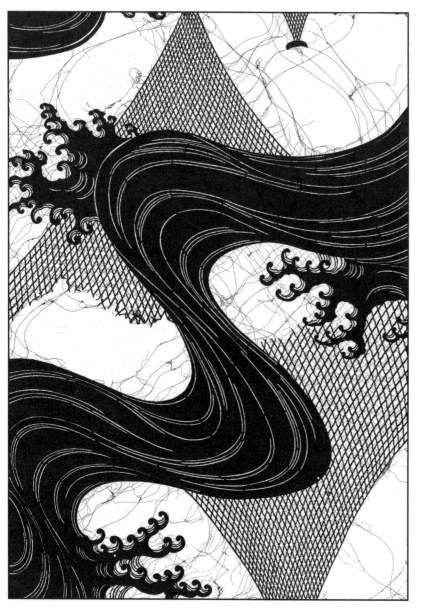

Japanische Motive für Flaäschenverzierung, Verlag der Blätter für Architektur und Kunsthandwerk, Berlin, n.d.

Geometric patterns
Motifs Géométriques
Geometrische Gegenstände
Motivos geométricos
Геометрические мотивы

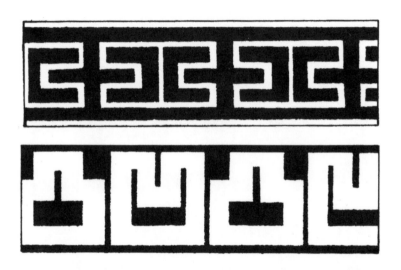

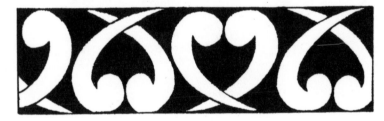

160-162:
Friezes.
Frises.
Friese.
Frisos.
Фризы.

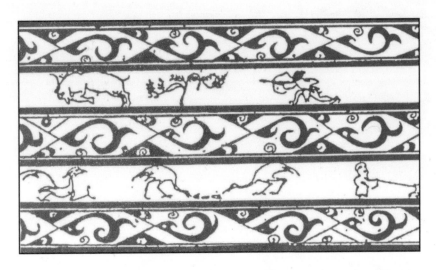

163:
Diagonal pattern.
Motif diagonal.

Diagonales Muster.
Motivo diagonal.
Диагональный узор.

163

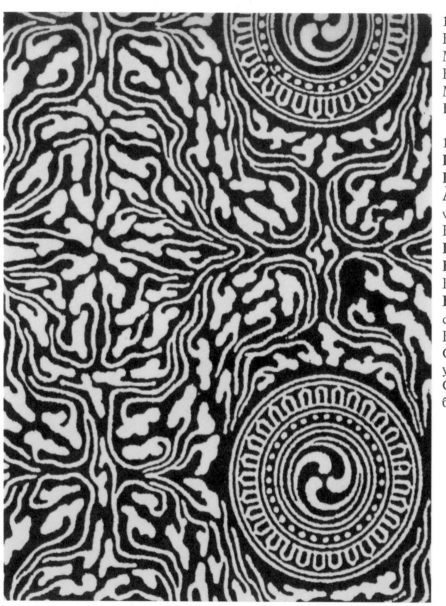

164:
Buddhist pattern.
Motif bouddhiste.
Buddhistisches Muster.
Motivo budista.
Буддистские мотивы.

165:
Left: Basketry patterns.
Right: Stylized bamboos.
À gauche: Motif de
vannerie. **À droite:**
Bambous stylisés.
Links: Korbmuster.
Right: Stilisierte
Bambusse.
Izquierda: Motivo de
cestería. **Derecha:**
Bambús estilizados.
Слева: Плетеные
узоры. Справа:
Стилизованный
бамбук.

165

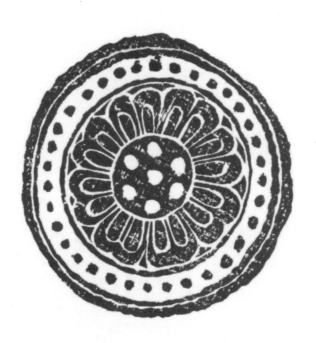

166-167:
Tiles.
Carrelages.
Fliesen.
Ladrillos.
Изразцы.

168:
Stripes.
Rayures.
Streifen.
Rayas.
Полосы.

169:
Swastikas.
Svastikas.
Svásticas.
Свастики.

170:
Diamond-shaped
stripes.
Rayures diamants.
Rautenförmige
Streifen.
Rayas diamantes.
Ромбовидный
орнамент.

171:
Left: Labyrinths.
Right: Circles and
ovals.
À gauche:
Labyrinthes. **À
droite:** Cercles et
ovales.
Links: Labyrinthe.
Rechts: Kreise und
Ovale.
Izquierda:
Laberinto.
Слева: Лабиринты.
Справа: Круги и
овалы.

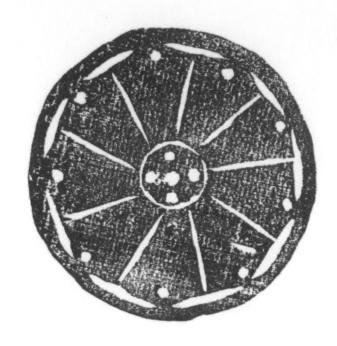

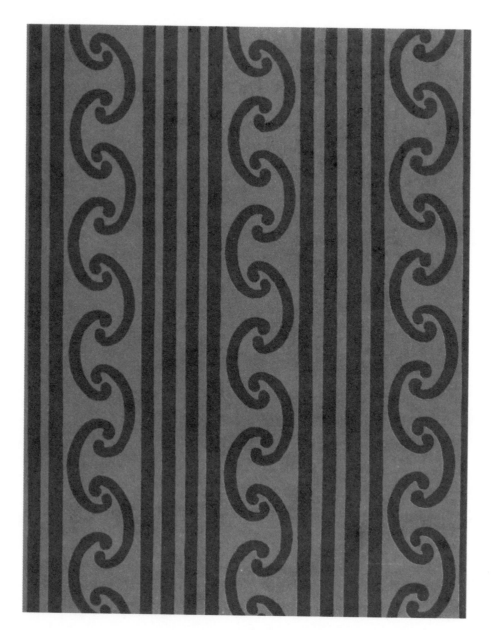

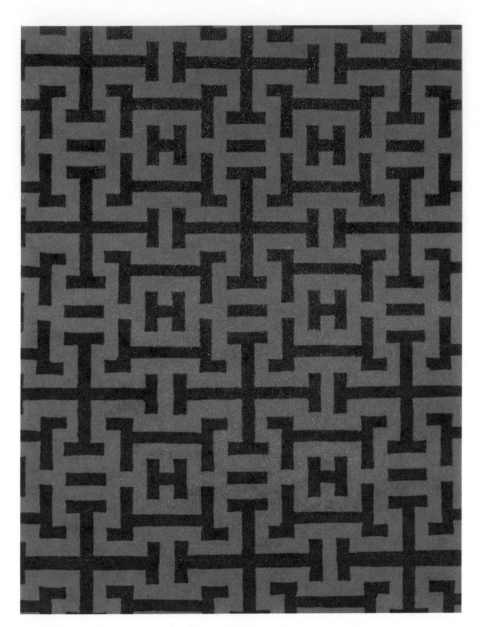

169

172

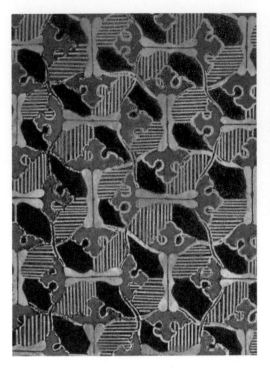

172: Stripes.
Rayures.
Streifen.
Rayas.
Полосы.

173: Left: Stylized leaves. **Right:**
Landscape.

À gauche: Feuilles stylisées. **À droite:**
Paysage.
Links: Stilisierte Blätter. **Rechts:** Landschaft.
Izquierda: Hojas estilizadas. **Derecha:**
Paisaje.
Слева: Стилизованные листья.
Справа: Рисунок рисового поля.

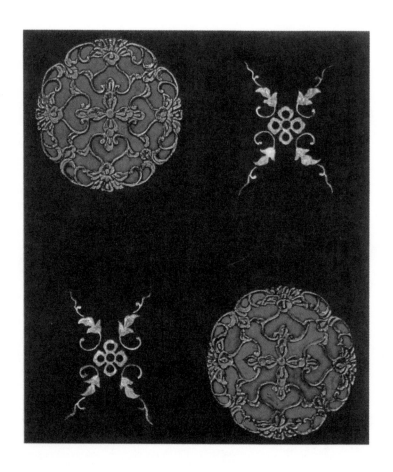

174: Marquetry.
Marqueterie.
Einlegearbeit.
Marquetería.
Маркетри.

175: Lacquer.
Laque.

Lack.
Laca.
Рисунок, покрытый
лаком.

George Ashdon Audsley.
*The Ornamental Arts of
Japan,* London, 1882.

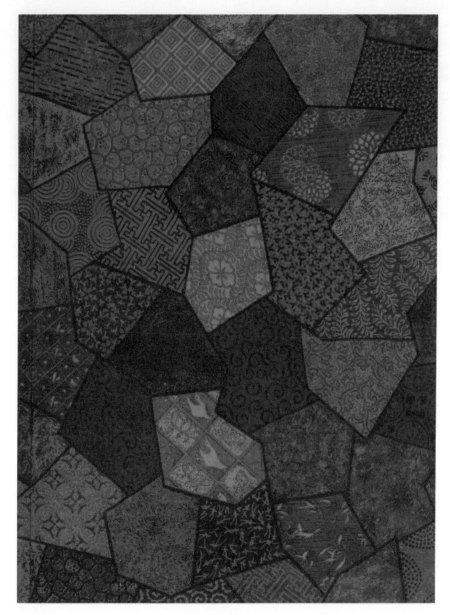

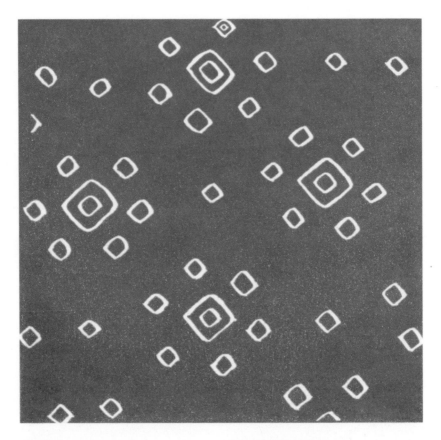

176: Diamond-shaped ornaments.
Ornements en forme de diamants.
Rautenförmige Verzierungen.
Ornamentos en forma de diamantes.
Ромбовидный орнамент.

177: Stylized flowers.
Fleurs stylisées.
Stilisierte Blumen.
Flores estilizadas.
Стилизованные цветы.

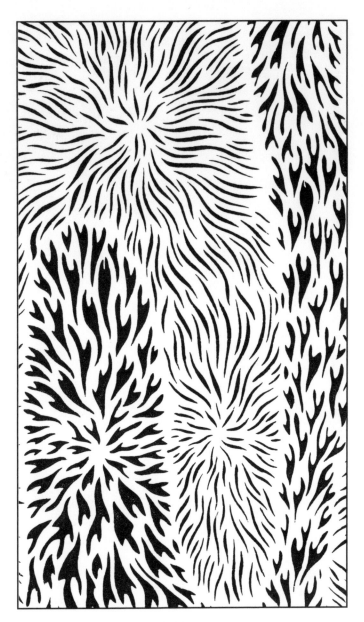

177

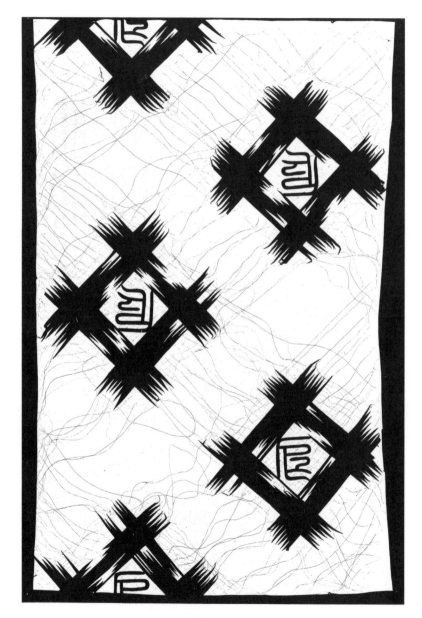

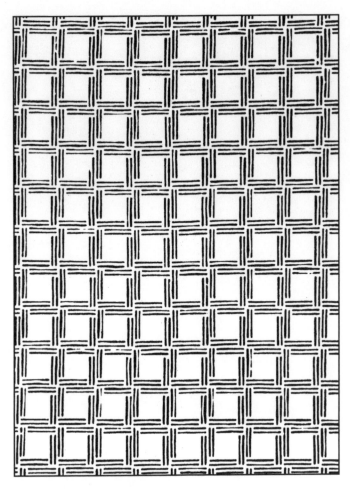

178: *Japanische Motive für Flaäschenverzierung,* Verlag der Blätter für Architektur und Kunsthandwerk, Berlin, n.d.

179-182:
Stylized Bamboos.
Bambous stylisés.
Stilisierte Bambusse.
Bambús esitlizados.
Стилизованный бамбук.

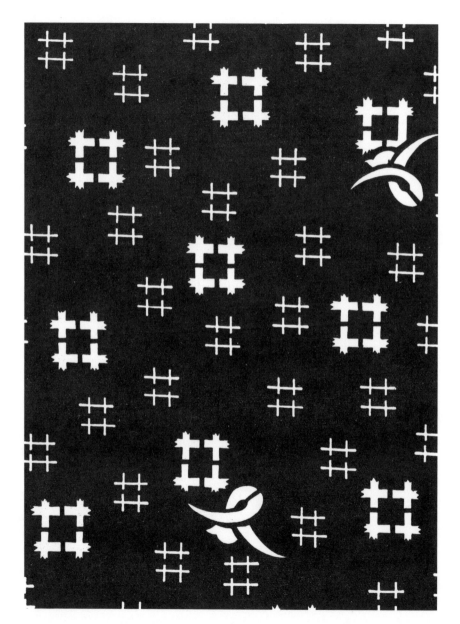

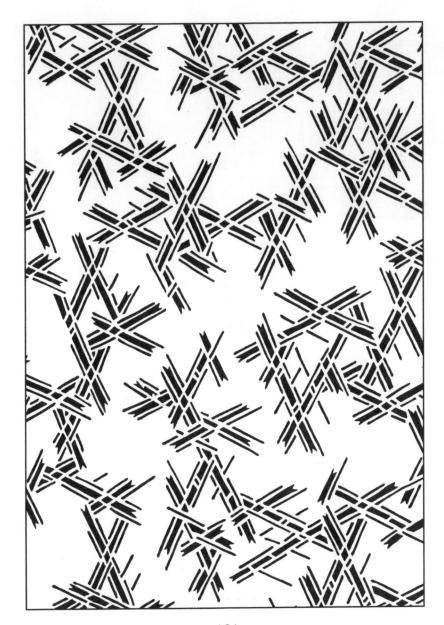

181

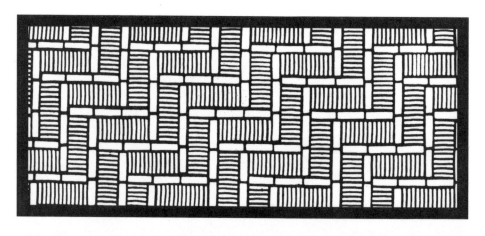

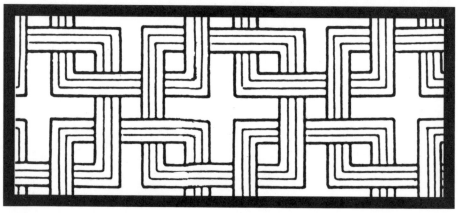

183: Stylized vegetals.
Végétaux stylisés.
Stilisierte Pflanzen.
Vegetales estilizados.
Стилизованные растения.

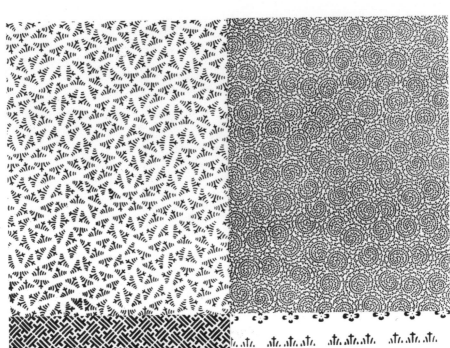

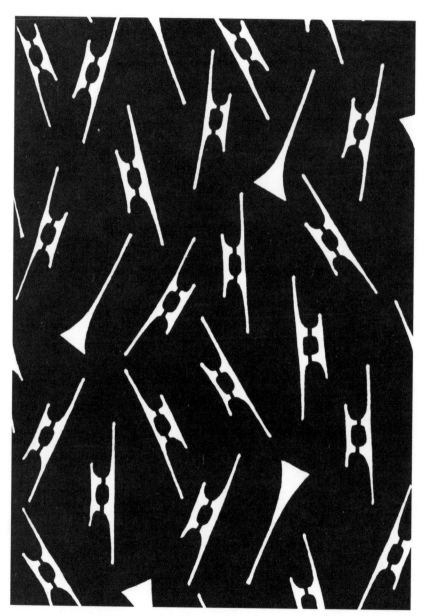

184:
Music instruments.
Instruments de musique.
Musikinstrumente.
Instrumentos de música.
Музыкальные
инструменты.

185:
Swastikas.
Svastikas.
Svásticas.
Свастики.

186:
Arabesques.
Arabesken.
Arabescos.
Арабески.

187:
Lattice pattern.
Treillis.
Gittermuster.
Cuadrícula.
Рисунок решетки.

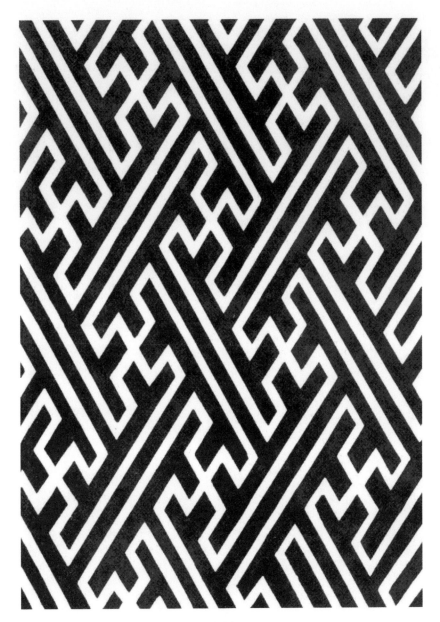

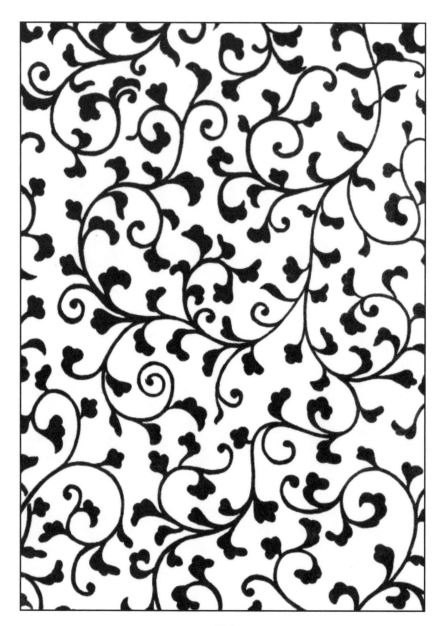

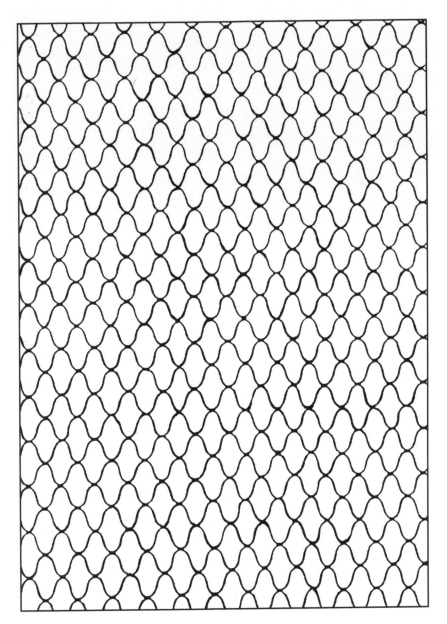

187

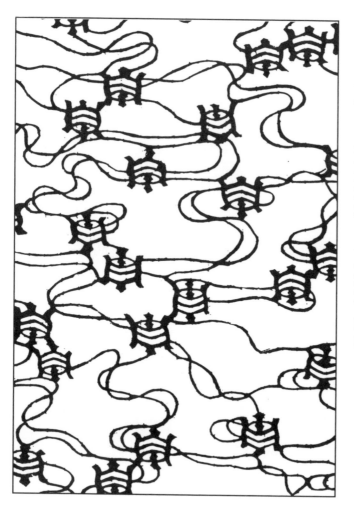

188-189:
Arabesques.
Arabesken.
Arabescos.
Арабески.

190:
Spots.
Points.
Punkte.
Punto.
Точки.

191-195:
Escutcheons.
Écussons.
Wappen.
Escudos.
Геральдические щиты.

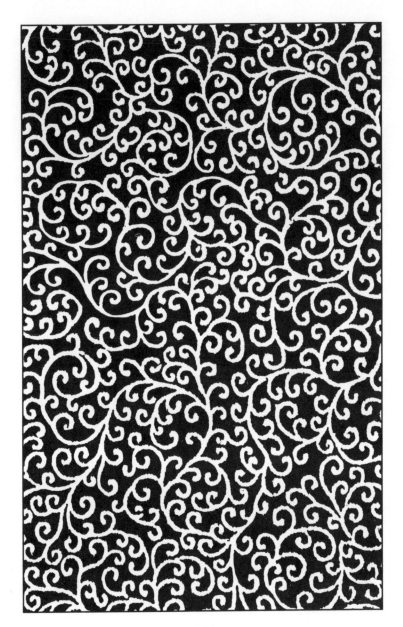

189

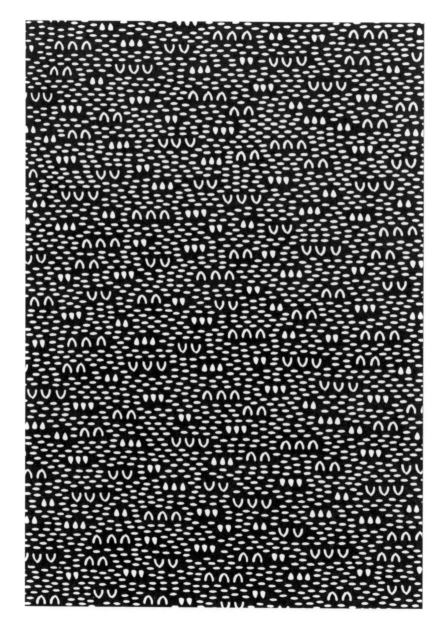

190

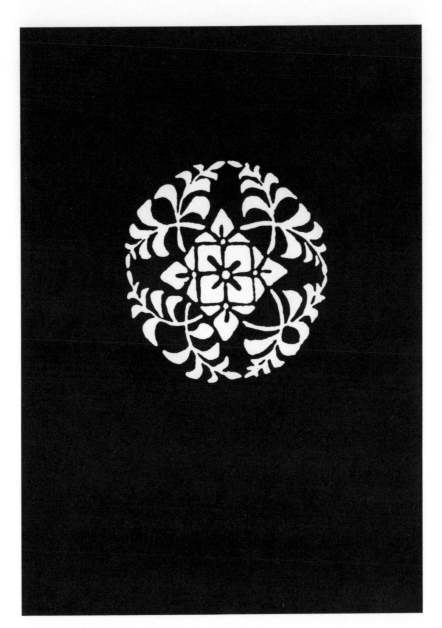

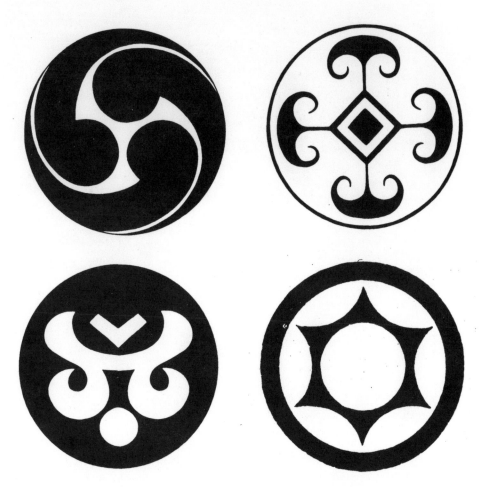

193-195:
Escucheons.
Écussons.

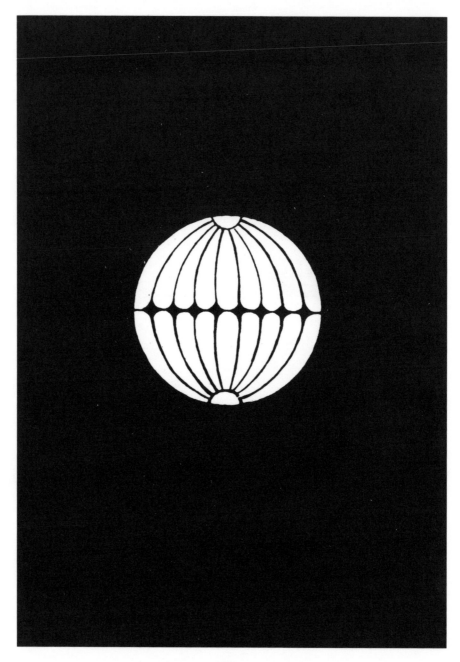

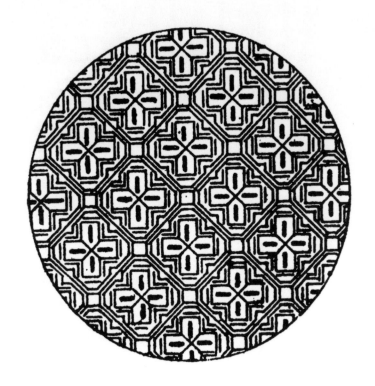

195

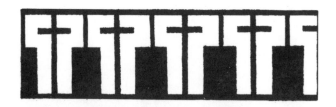

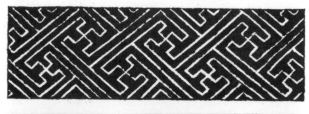

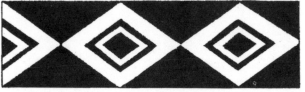

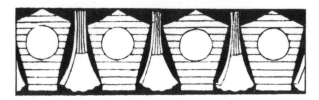

196:
Friezes.
Frises.
Friese.
Frisos.
Фризы.

197:
Diamond-shaped pattern.
Motif en forme de diamant.
Rautenförmiges Muster.
Motivo en forme de
diamante.
Ромбовидный орнамент.

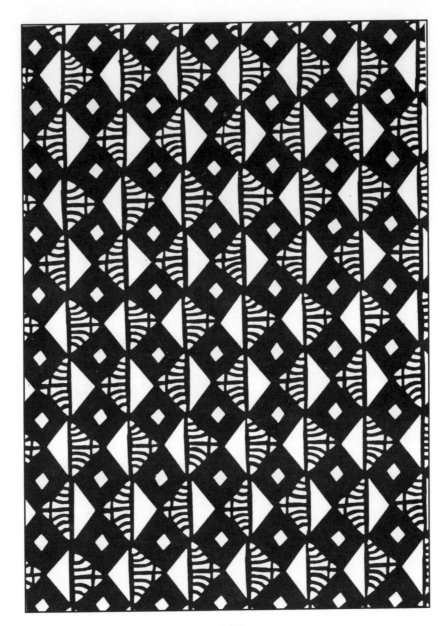

197

198-200:
Friezes.
Frises.
Friese.
Frisos.
Фризы.

201:
Arrows.
Flèches.
Pfeile.
Flechas.
Стрелы.

202-203:
Friezes.
Frises.
Friese.
Frisos.
Фризы.

204-205:
Diamond-shaped patterns.
Motifs en forme de diamants.
Rautenförmiges Muster.
Motivos en forme de diamantes.
Ромбовидный орнамент.

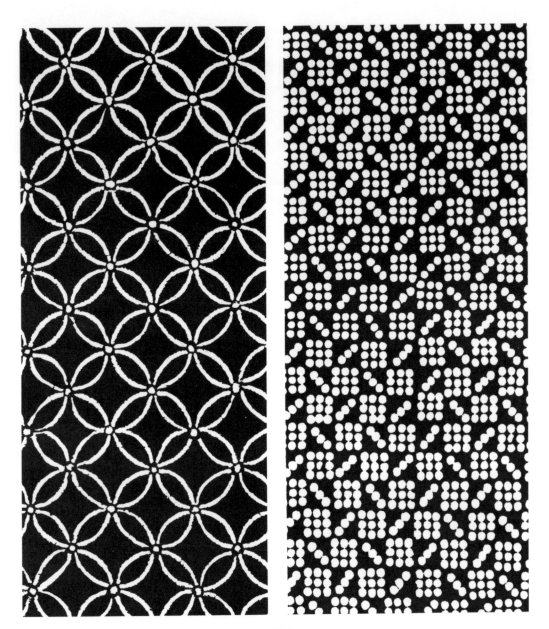

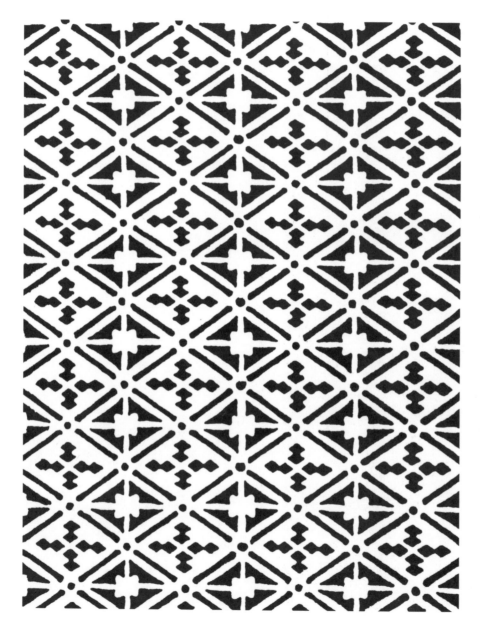

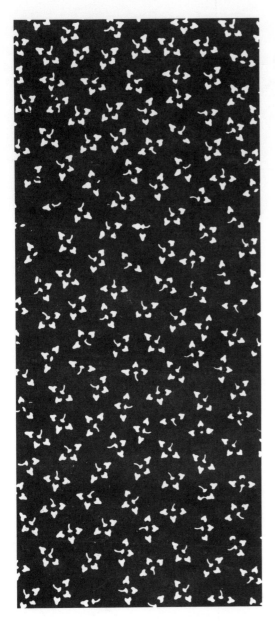 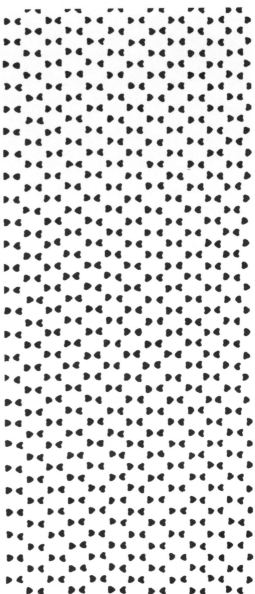

205

Achevé d'imprimer
en Slovaquie
en juin 2005

Dépôt légal 2e trimestre 2005